New Life Clarity Publishing

205 West 300 South, Brigham City, Utah 84302
Http://newlifeclarity.com/

Printed in the United States of America
ISBN- 9780578777221
Copyright@2020 Judy-Lee Chen Sang

Dedication

To all the women before me who met the challenge and those who did not, thank you.

To Yola, my sister who valiantly fought for herself and her family in 2020.

To Lauren for allowing me to be free in my body and for capturing me in my experience of exquisite beauty.

To my family and friends, who were there to support me. Without their vision, their compassion and their ability to gather up the troops, sitting with me for hours at doctor's appointments, walking me through insurance procedures, food trains and companionship, this journey would have been lonely.

The persons who offered their ears as I cried and didn't know what to do. There are many hands at the source of this creation and every one of you knows who you are. You kept me creating myself to be braver than I knew myself to be.

I am forever grateful for all of what you have contributed and continue to contribute to my life and the vision I have for all women living in dignity and having the choice to make decisions about their own bodies.

I CRY

Hope meditation and guidance

Judy-Lee, 2020

What is mastectomy? What is a double mastectomy? What are the benefits of a double as opposed to a single? What is the prognosis? What type do I have? How can I find a surgeon? What does my insurance cover? Do I get time off from work? What do I need for my recovery? How long is the recovery? What size do you want to be? Do you want implants, DIEP Flap or go flat? What is DIEP? How long has the plastic surgeon worked? What is their rating Who will support me? Do I have enough money to cover it all? What about…? It never stops…

‖ *I never learn anything talking. I only learn things when I ask questions.*

Lou Holtz ‖

Be available to find resources to assist in sorting it all out.

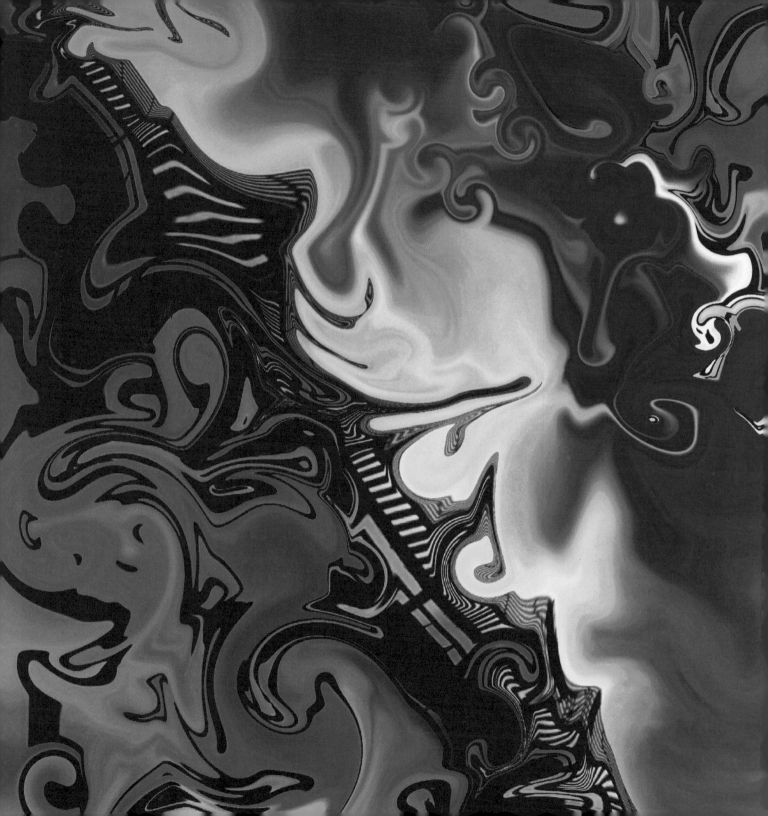

The news is here and the ride has started with or without you. Hold on tight and breathe.

Find solace in knowing that you will discover things about yourself that you never knew before. Let your loved ones know what you are about to embark on, even if you are unsure. Sharing your fear, your anxiety and your trepidation will bring everyone on the ride with you as well

‖ *The journey of a thousand miles begins with one step.*

Lao Tzu ‖

For family and friends you too are on the journey with them. Be gentle on yourself and your loved one who is dealing with this life altering news.

Life is chaotic and stressful. Things are unraveling around you and there is no clear path for your answers. Breathe, center yourself and get guidance and comfort. Community is the key to your strength.

Real knowledge is to know the extent of one's ignorance.

Confucius

For those around seek out information and ask lots of questions. Do not assume anything. Be there sometimes to just listen.

The pieces of the puzzle don't fit. As you spiral out of control into the abyss there is only darkness. It seems like you will never be able to navigate the various pieces towards getting the answers. The appointments, do I need an oncologist? Surgeon? What does the insurance cover? By when do I need to decide? And it keeps coming.

When the world pushes you to your knees, you're in the perfect position to pray.

Rumi

Be the person who is consistently at your loved one's side taking notes in all appointments. They will not hear what is being said and will not remember with everything coming at them.

There is so much information coming at you in short order, it feels like the winds of the hurricane pounding at the door screaming to come in. The frantic blowing of the winds whipping through the storm trying to stand firm against the irate destroyer. There are tests, appointments, research, questions, answers, more questions and no answers. All the while the fear grips at your belly. And then there is more.

‖ *I am too weary to listen, too angry to hear.*

Daniel Bell ‖

Be available to go over questions before the appointments and then go to fill in on questions and write down the answers.

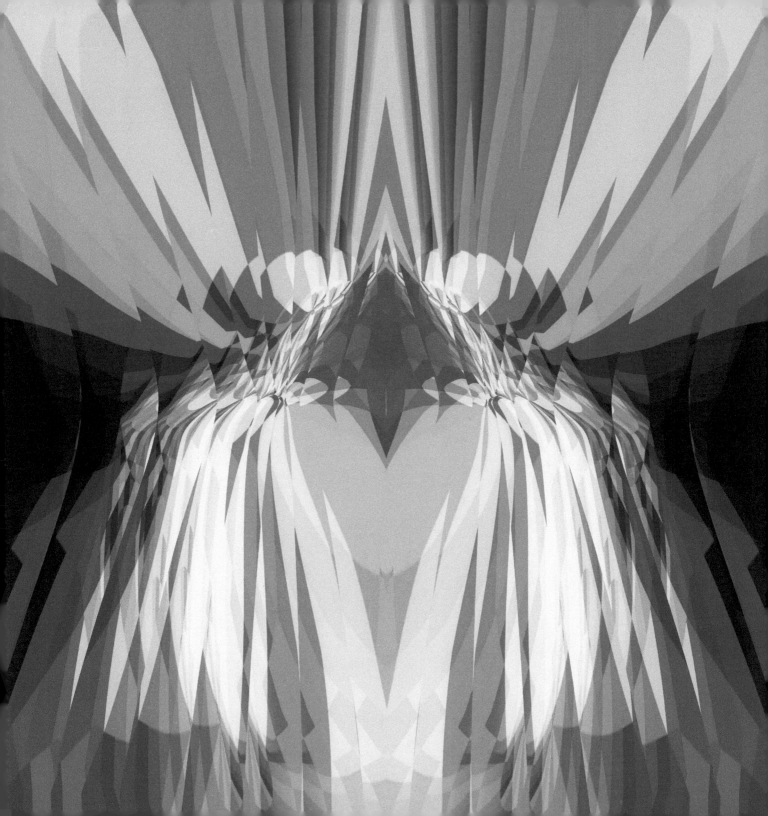

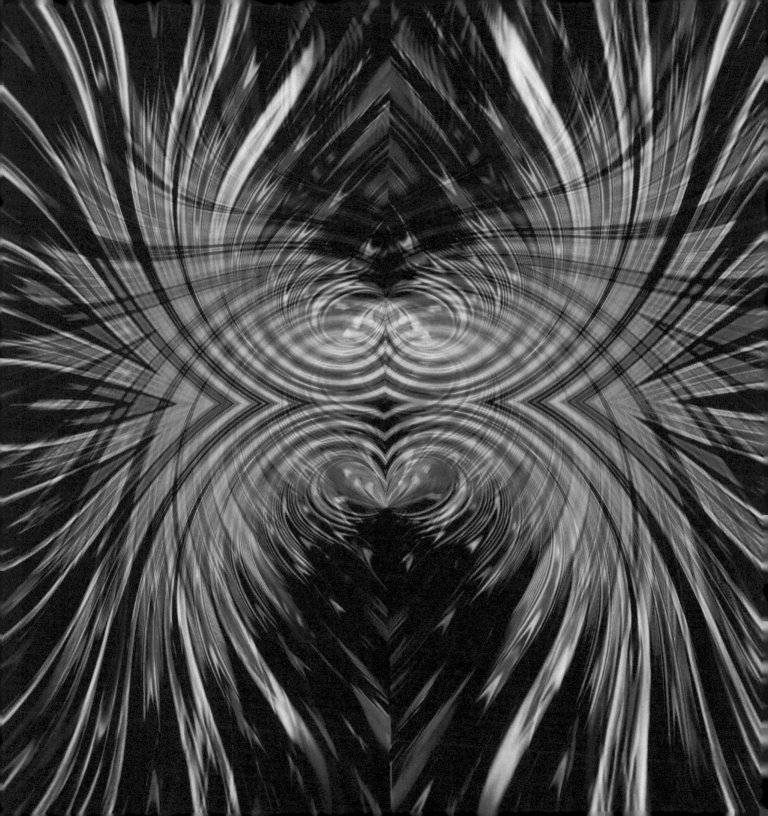

The ability to say no to what does not provide you with freedom and ease bounces against the backdrop of what should be or what others may want. Decisions are usually entangled in this web of turmoil and uncertainty of yours and others. This is too much information to process. Can someone else make these decisions? Who is the best person to guide me? Where do I go?

‖ *I only ask to be free. The butterflies are free.*

Charles Dickens ‖

You are helpful when you are available to be a sounding board to free up their thoughts.

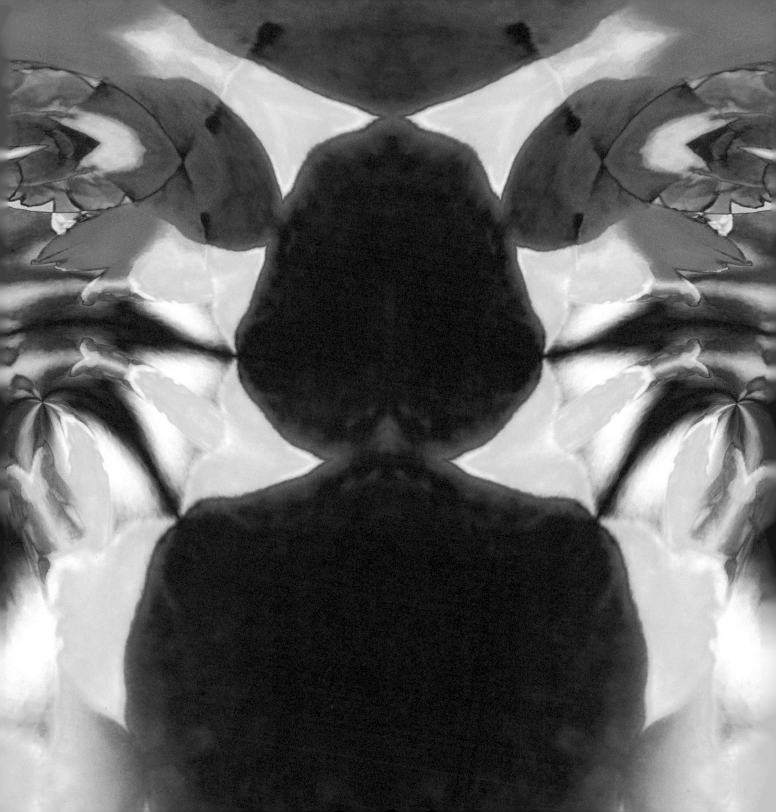

"If you realize that all things change, there is nothing you will try to hold on to. If you are not afraid of dying, there is nothing you cannot achieve."

— *Lao Tzu*

I cry

Anticipate the difficult by managing the easy.

Lao Tzu

Research and prepare ahead of time for their transition home after surgery. Many hands make the burden lighter.

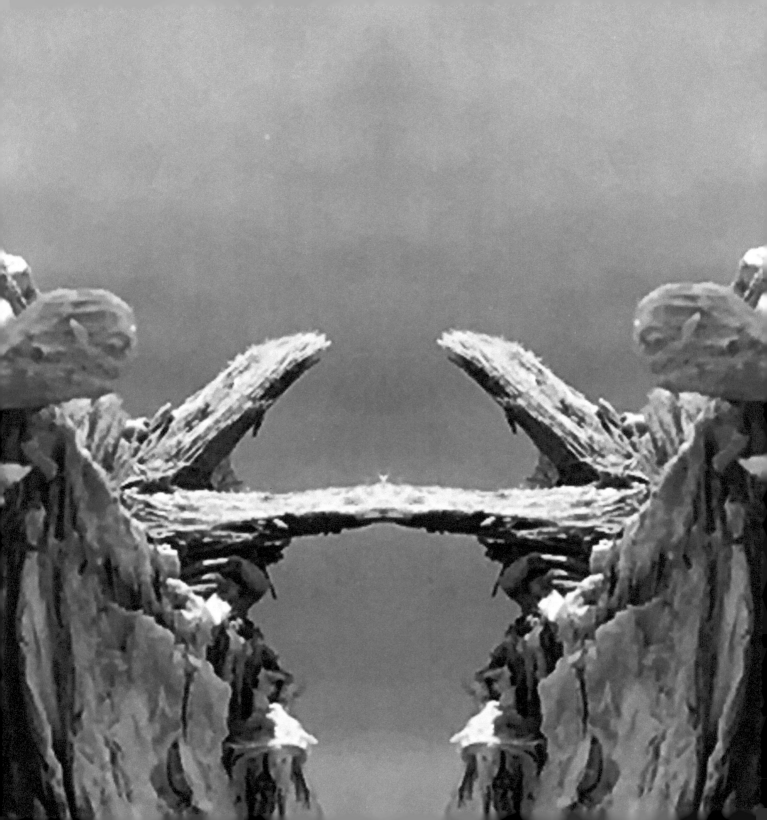

Bridge over troubled waters, as you lay down to sleep there is no rest. Worry seeps through every pore. Darkness gives the body time to heal and regenerate. Soothe yourself with relaxing music and thought.

My heart sings with the glory of the unknown. Inside the not knowing new ideas emerge.

Judy-Lee

Compile a music list and give as a gift to your loved one.

DCIS – Ductal Carcenoma Insitu is cancer so don't tell me I don't have cancer. It is a radical reality that one engages in. Do I have cancer or not? It is pre-cancerous, so is it deadly? If it is pre-cancerous and not deadly, then why do I need this aggressive treatment? Why don't I have breasts, or hair? Why am I torn?

|| *When angry, count to four; when very angry, swear.*

Mark Twain ||

Anger and confusion are real emotions your friend or loved one is feeling. Give them a pillow to punch or take them to the batting cages to express the anger. It is real and needs to be expressed. Yes, DCIS is cancer. Please do not say – well at least you didn't have cancer, or it's the best type of cancer you could have. Even Stage 0 can leave devastating results that mimic later stage cancers.

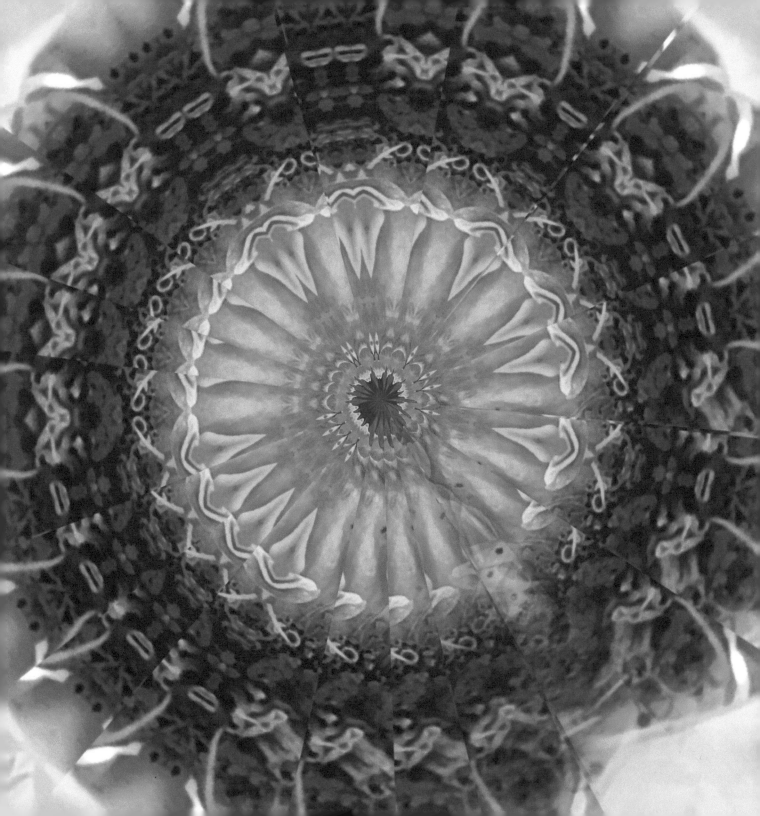

I feel like a pinwheel being blown in the wind. The direction is not my own. My life is not mine and I am at the effect of this thing that is in my body and all the outside voices that control my every action and thought. There is no decision that is mine.

Will I ever find joy again in living life?

JOY

1: the expression or exhibition of such emotion: gaiety

2: a state of happiness or felicity: bliss

3: a source or cause of delight

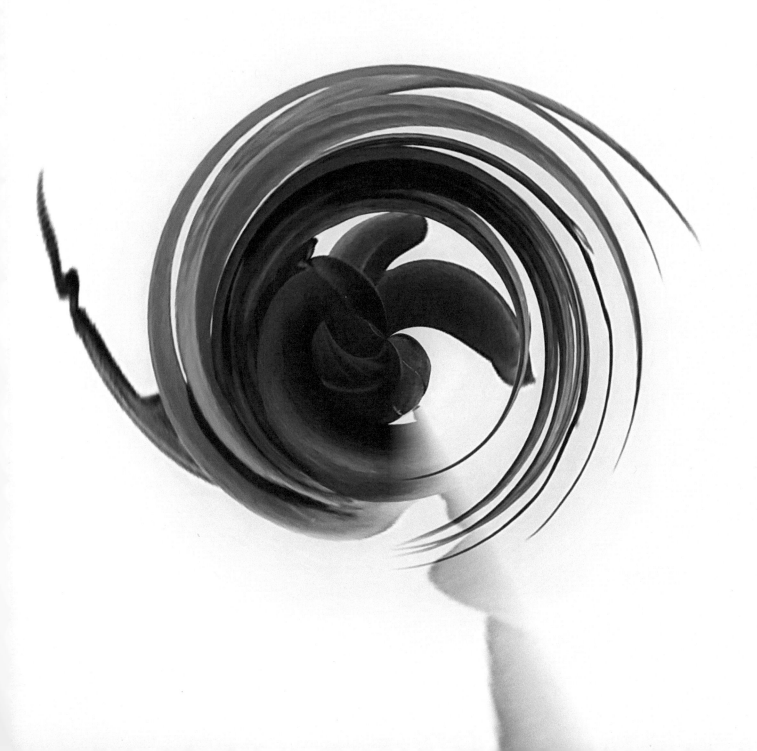

Through the darkness of your mind's eye is the constant fear that envelops you. It pulsates in no special rhythmic fashion, yet it is a constant reminder of cancer. Will it come back? Did they get everything? Then you breathe and get present to what is in front of you, and you sigh.

|| *No legacy is so rich as honesty.*

William Shakespeare ||

Gratitude is never far from a survivor's being. They live in gratitude and the fear is real. Allow them to have their feet in both places.

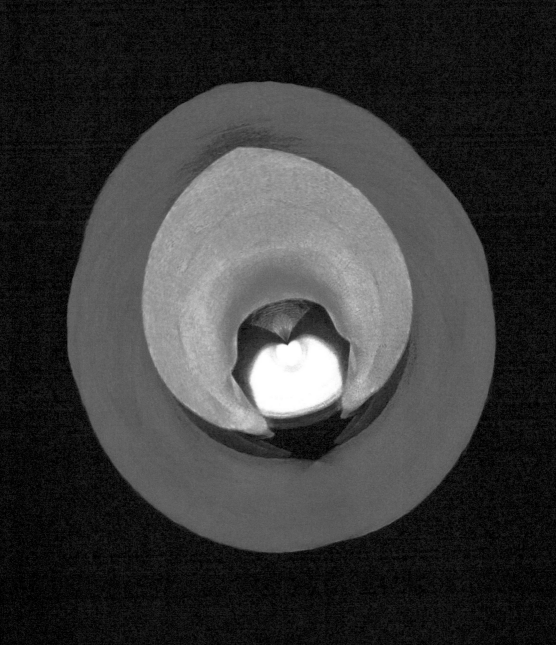

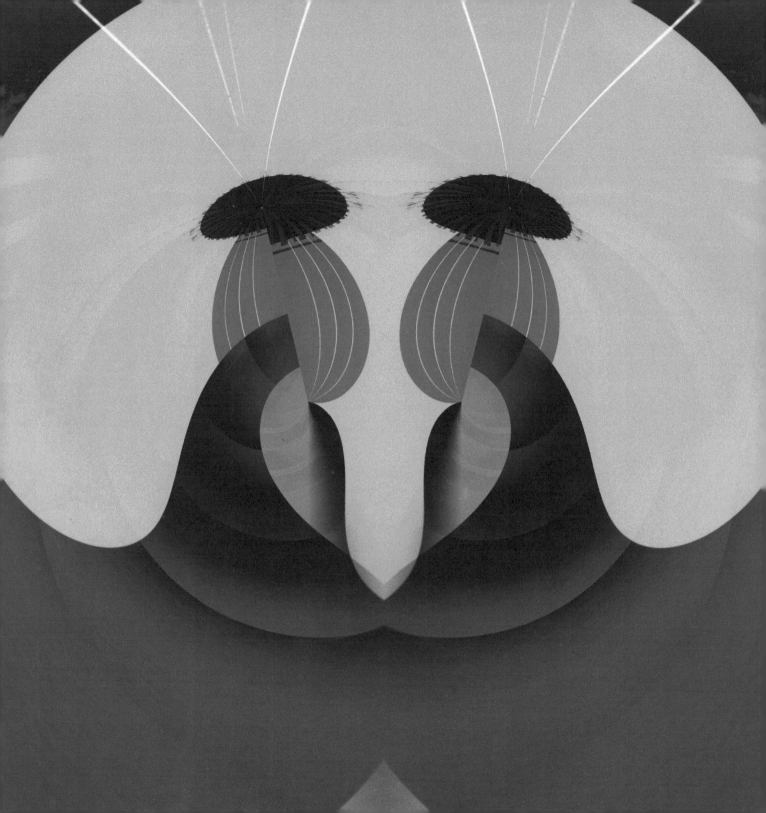

The only thing you want is a kindred soul to speak to. Someone who understands the actual journey and more often than not, there is someone waiting to share their story with you.

Real knowledge is to know the extent of one's ignorance.

Confucius

Knowing someone who has had cancer or a mastectomy does not make you an expert. Listen. Love. Comfort your loved one. Find someone who has what they have and connect them.

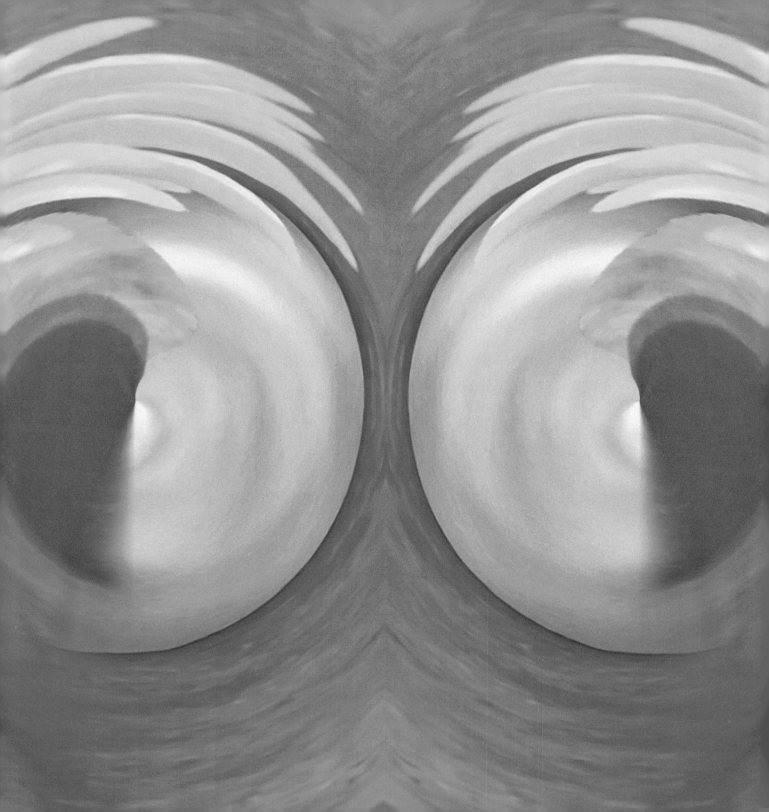

Breasts, breasts, breasts
Everywhere you go you think about breasts. The prospect of not having breasts lets the mind wonder and linger on looking at breasts.

> *Vanity and pride are different things, though the words are often used synonymously. A person may be proud without being vain. Pride relates more to our opinion of ourselves, vanity to what we would have others think of us.*
>
> *Jane Austen*

Breasts do not make a woman. Intellectually that is known, yet for your loved one this is the body they know and imagining it any other way is difficult. Whether they are flabby, drooping, humongous or just right, this is what they have known since puberty. Allow them to be irrational. This will pass with love and acceptance.

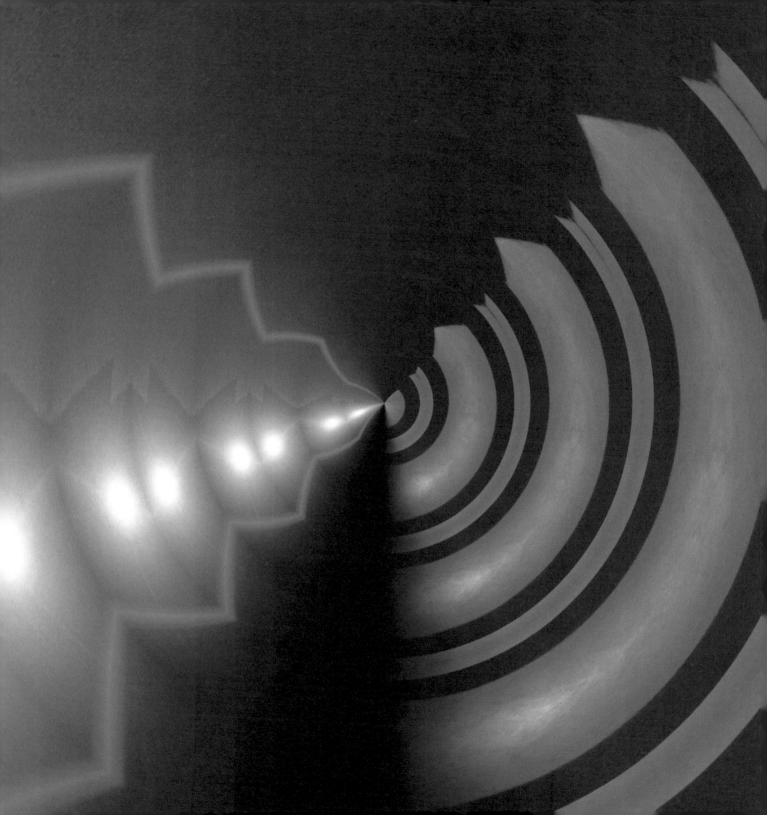

Electric shocks, needles and pins pricking the inside of the hollow breast area is unnatural. They are a constant reminder that life after cancer is still not normal. There is a new normal to discover and be with. And yet these pains tell you that your nerves are connecting again. There may be some hope for feelings to return to this area of your body. How do you describe what you feel? How do you share the intimate details of your pain? Will anyone ever truly understand? It is a challenging and lonely journey.

|| *These pains you feel are messengers. Listen to them.*

Rumi ||

This is the time you ask questions and listen. It is not the time to say "just move on" or wonder why they are still not totally engaged with life. They need gentle love and understanding.

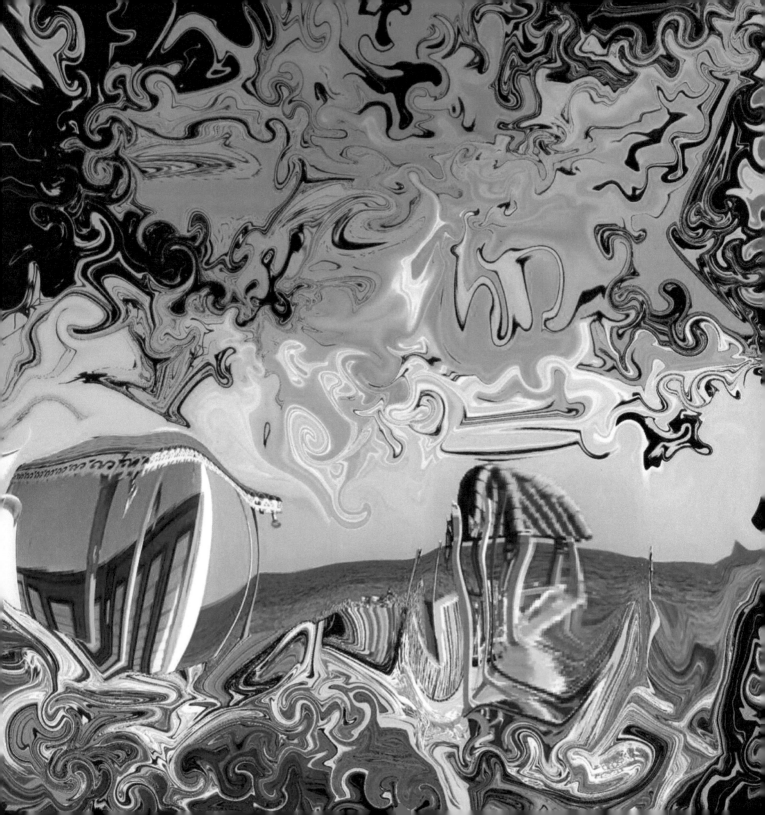

The ocean breeze and the smell of the ocean fills my lungs with comfort. Oh how I wish I was there right now.

> *"I felt once more how simple and frugal a thing is happiness: a glass of wine, a roast chestnut, a wretched little brazier, the sound of the sea. Nothing else."*
>
> *— Nikos Kazantzakis, Zorba the Greek*

For the caretaker, where is your healing place? Go take a moment and relax and unwind. Drink a glass of wine with a friend. Laugh.

Life has twists and turn. Ride the corners, look ahead. Have fun. Trust it.

Judy-Lee

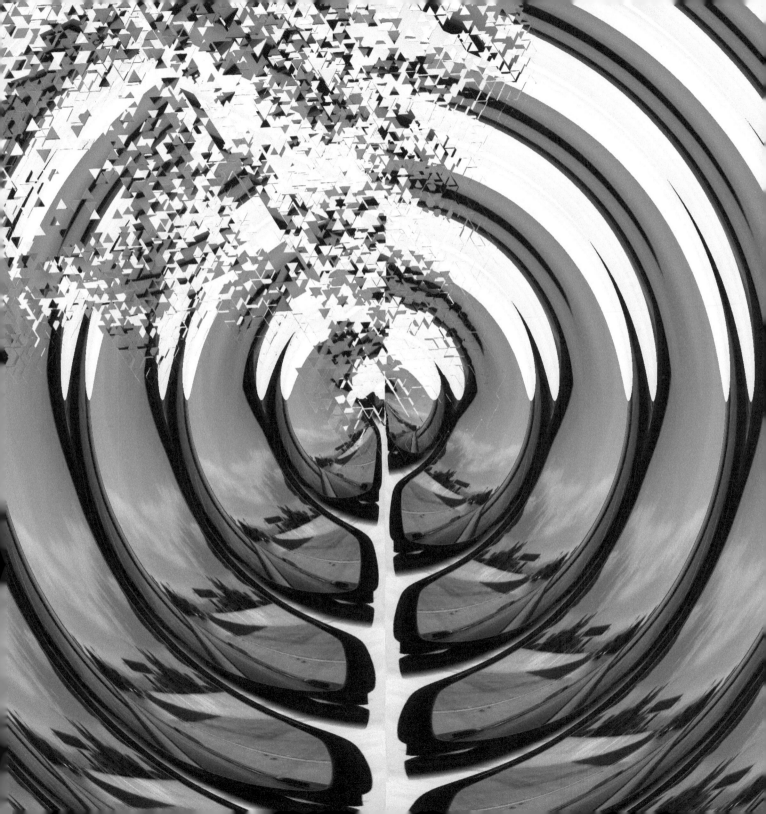

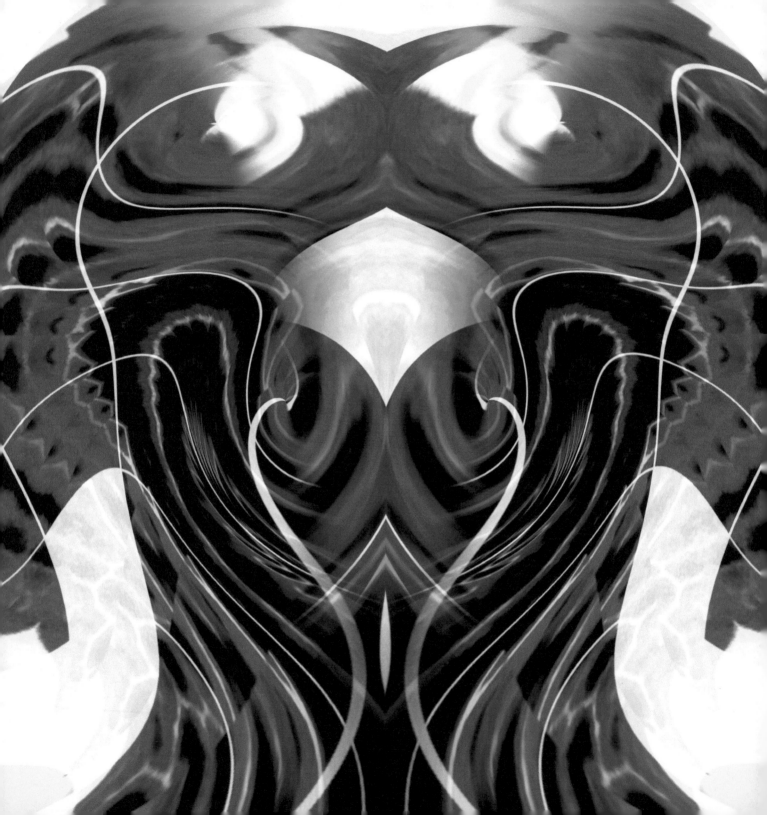

Your body is no longer yours. It is a figment of your imagination. You look in the mirror and the amputated vision that reflects back with scars and tubes shocks the innermost sanctity of your core. Take your time to be with this body that has betrayed you. It is okay to be angry, sad and disconnected.

‖ *No legacy is so rich as honesty.*

William Shakespeare ‖

It does not get better just because you want your loved one to heal. Allow them the space to absorb and process the distortions they see. Listen.

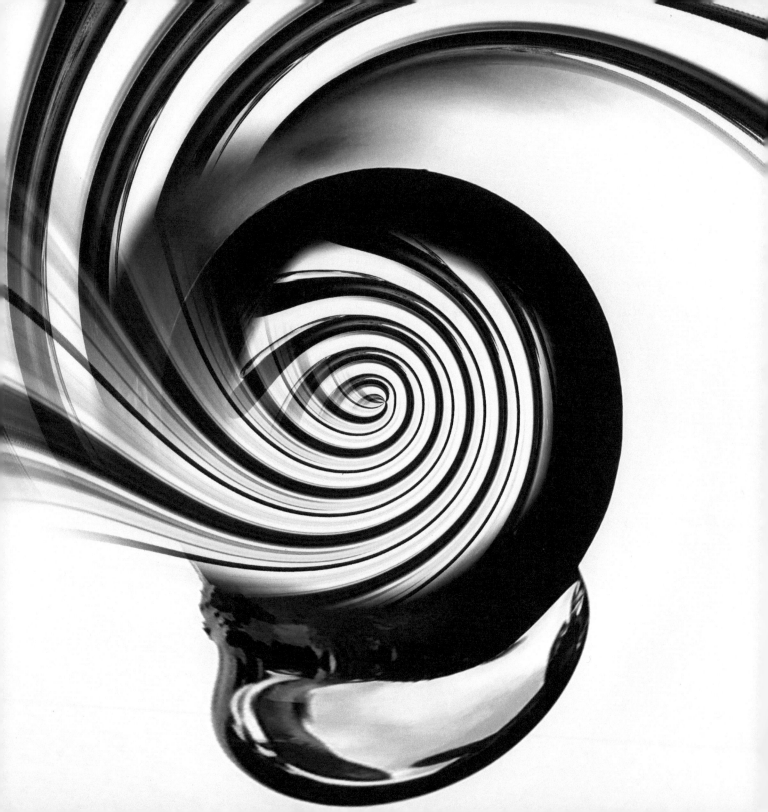

Rain drops keep falling on my head and I keep looking for the storm to be over, and it still lingers. Drop by drop.

|| *You weep and this heals. Let it go and let it out loud.*

Judy-Lee ||

This is the time when abject fear sets in for everyone. Make sure you are getting help yourself. You cannot be helpful if you are not getting oxygen for yourself. Allow them to cry and to be alone.

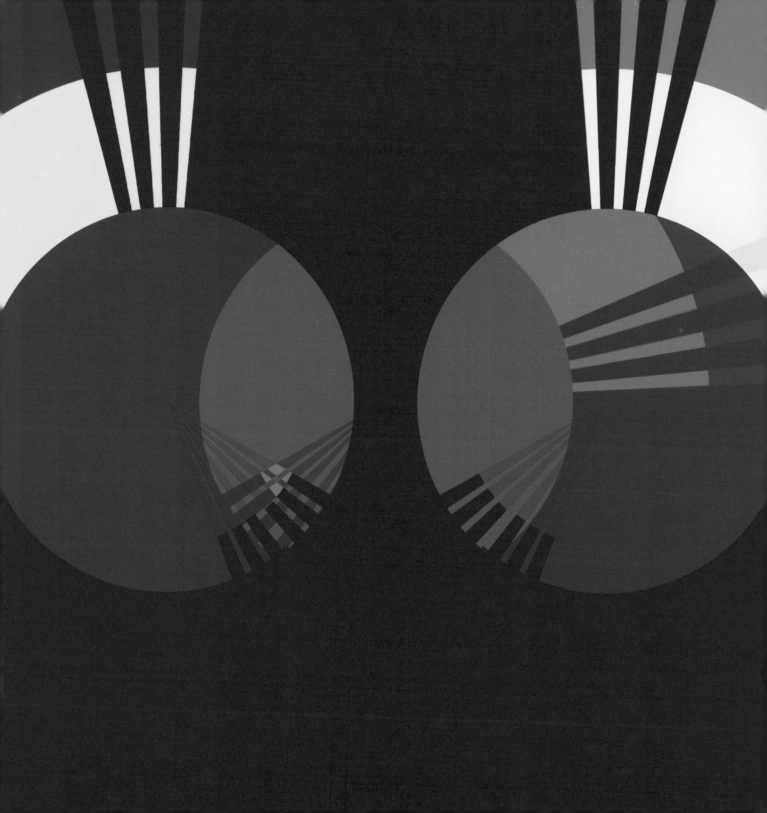

I am a woman.

I am a Black woman.

I am a mature Black woman.

I am a mature Black woman with curves.

I am a mature Black woman with curves with breast cancer.

I am a mature Black Woman with curves with breast cancer who had no other choice but mastectomy!

Where do I find pictures of me out there?

They do not exist.

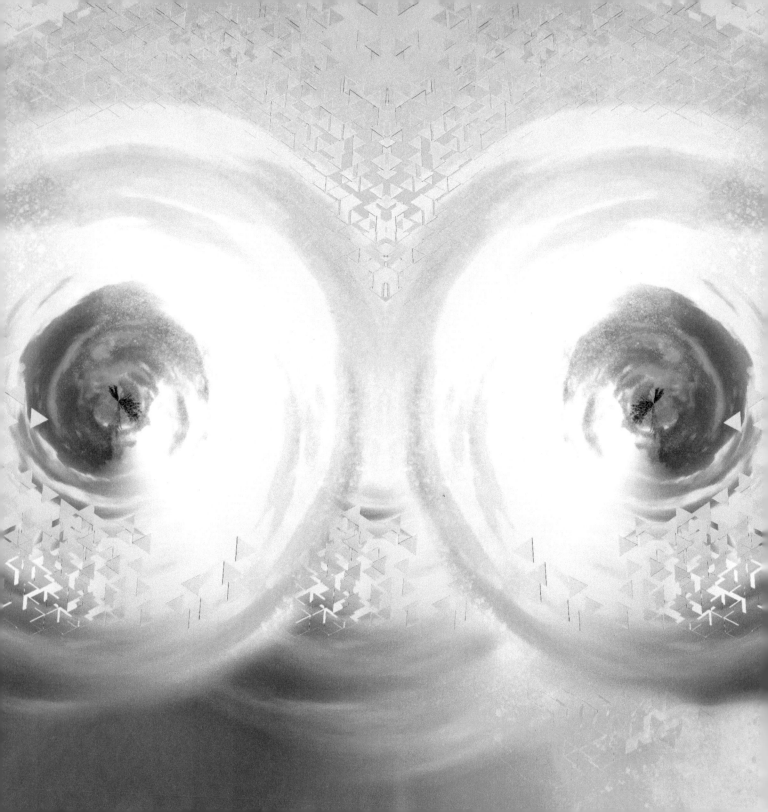

But you will have perky breasts! Frustrating hearing these words time and again. You just want to scream and shout! I just want my breasts. I never wanted perky breasts. It was never on my mind.

Sincere words are not fine; fine words are not sincere.

Lao Tzu

Words are hurtful. Your loved ones are in a very vulnerable place and insensitive words bring pain and anger. What you may think is funny may be cruel. Think about what you are saying before you say it. Get into their world.

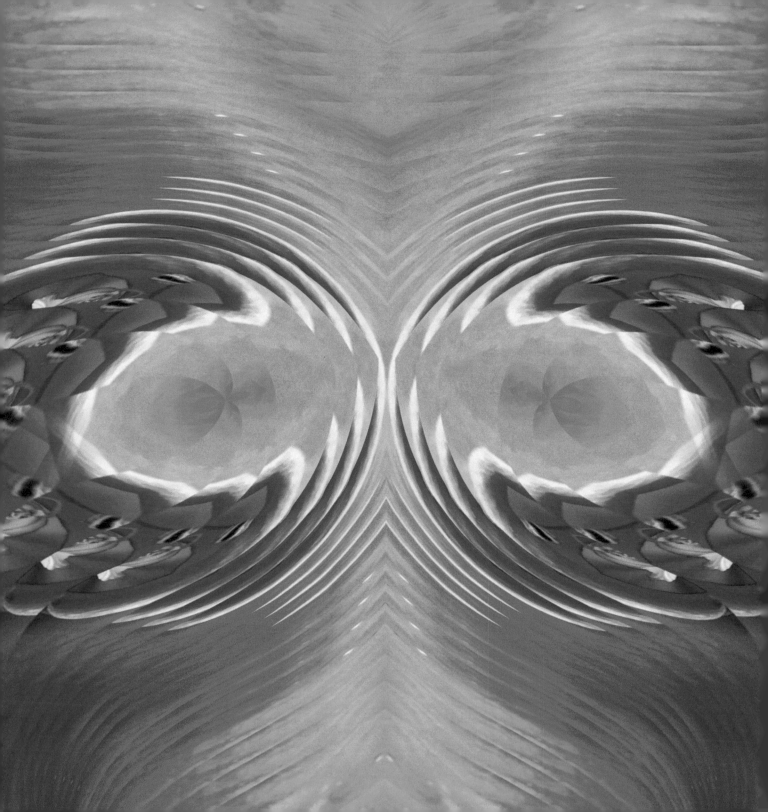

Fuck it! Fuck Cancer!

‖ Care about what other people think and you will always be their prisoner.

- Lao Tzu ‖

There is anger and pain and you may hear it frequently or not. Be there to just listen.

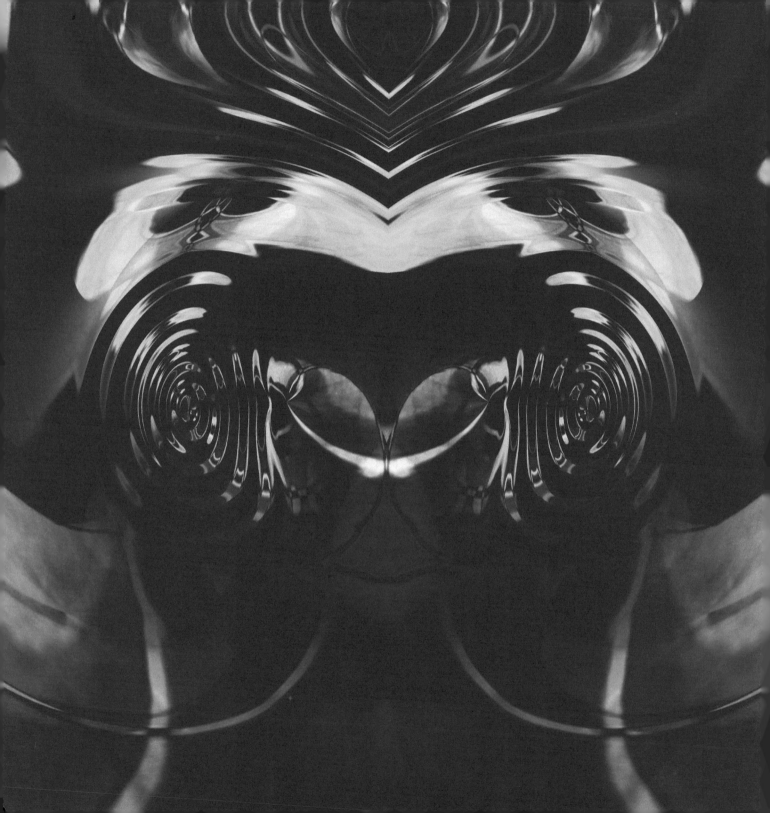

No, I don't want to have my breasts removed. Isn't there something else that can be done? How do you come to terms with your body? There is so much I wanted to do? How do I deal with intimacy? The scars. The destruction of woman.

> *Courage is not having the strength to go on; it's going on when you don't have the strength.*
>
> *Theodore Roosevelt*

Every woman processes the impending decision differently. No two scenarios are the same. Some are happy to just get it over with and to live. Others have the burden of losing a part of their soul. Their inner core and their life. It will take time for the latter to adjust, and it's on their time, not yours.

The mind is like a time bomb waiting to explode with the amount of activity it experiences. It's like the tick tock of the clock dancing on a shelf. It vibrates with thoughts and leaves little room for rest. Go slowly and give pause. Embrace your fears and ask for help. Go talk to a professional if necessary.

|| *It does not matter how slowly you go as long as you do not stop.*
Confucius ||

Anxiety and doubt creeps into the psyche of your loved ones. Ask if they are getting professional help and support.

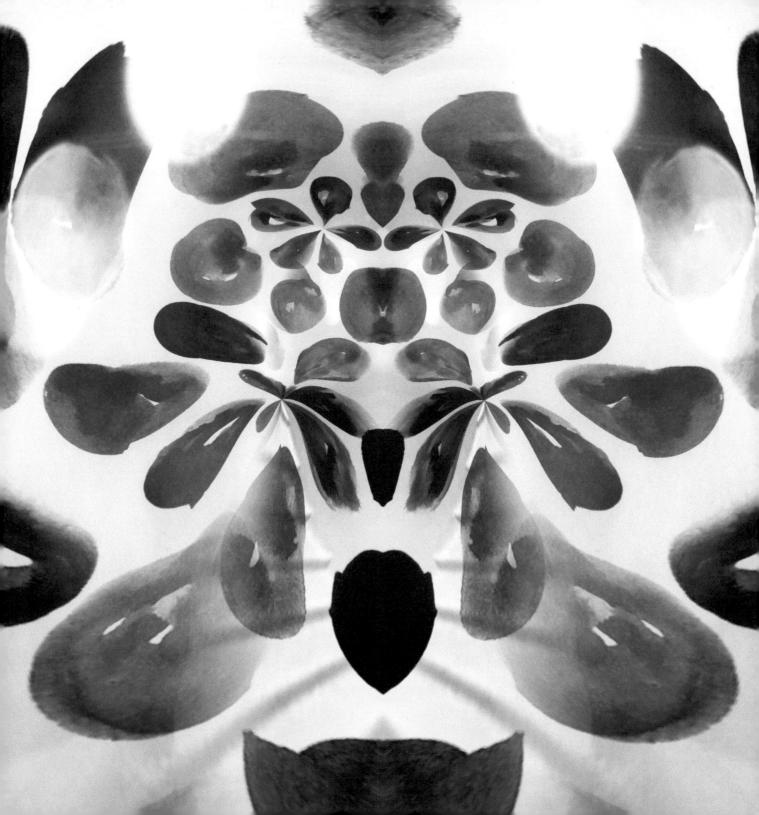

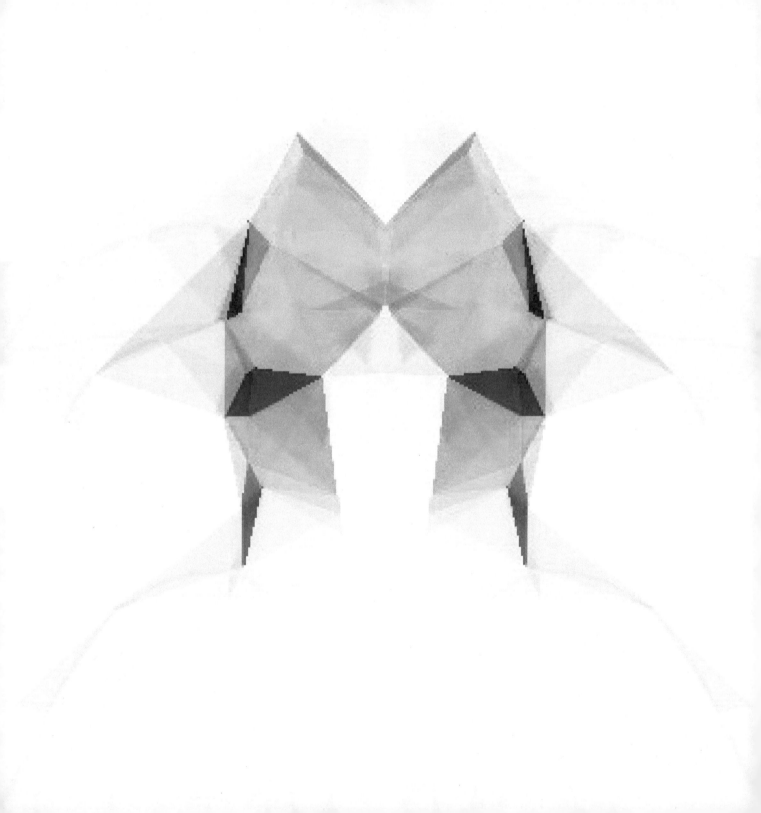

Who do I see in the mirror? What is that? It's not me. I don't remember what I look like with breasts. The moment you look in the mirror and cannot remember what you look like with breasts is the day that you curl up in a ball and bawl like an unattended baby. Let it out!

The only lasting beauty is the beauty of the heart.

Rumi

This is when you open your arms and hold your loved ones tight. Say nothing and allow them to grieve. Love them fiercely.

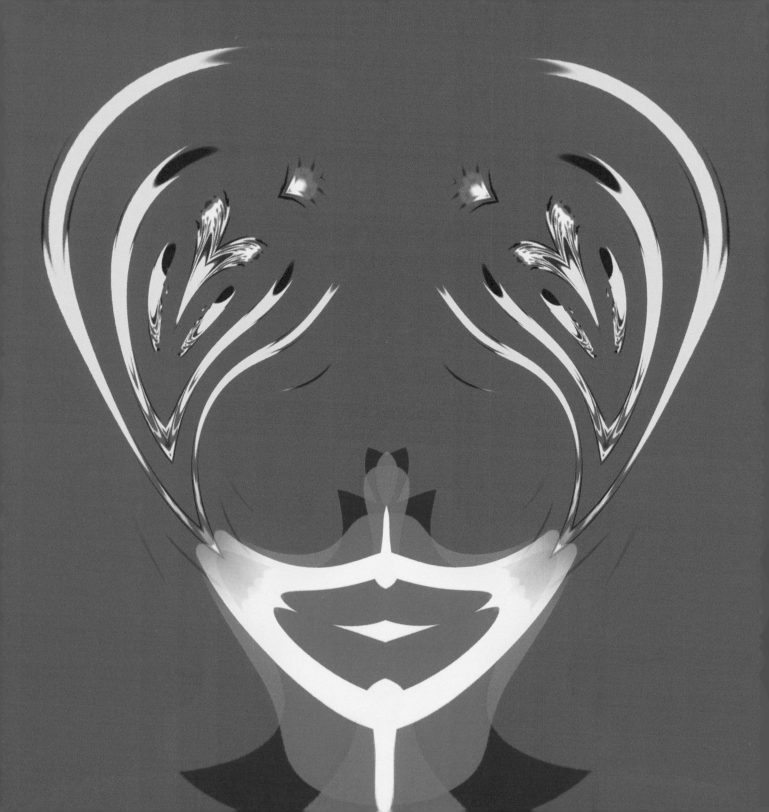

That moment when you come to terms with what has happened to you; your body is amputated. It is a limb that has been cut off. You need to go to physical therapy to regain movement and you may have an appendage through expanders or implants. To others you appear to be normal and strong, however, behind closed doors, in the privacy of your soul you know you are a freak.

The wound is the place where the light enters you.

Rumi

No matter how much you say to your loved ones, they look good or look normal, remember for them, their view is what matters. Have patience and be gentle.

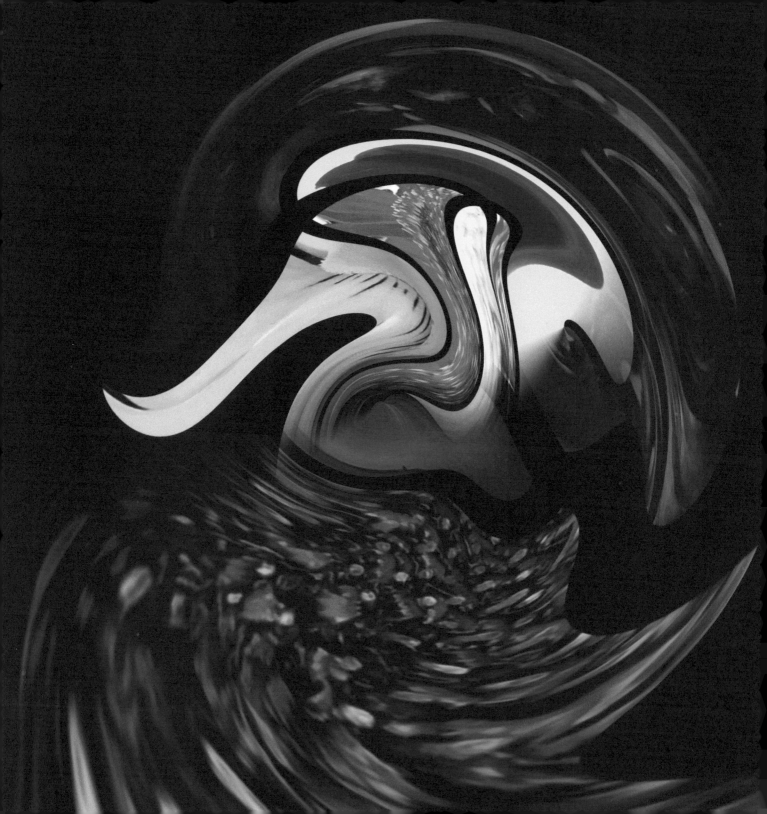

Distorted is how I relate to myself. The scars heal and are permanent reminders of what was and what will never be. There is numbness and you can no longer tell when your clothes are exposing you. You cannot feel hot coffee spill on your chest and people stare. You walk out and wonder who is looking? What are they thinking? Will life ever be normal. Then you hear, it's a new normal....whatever that means.

Don't be satisfied with stories, how things have gone with others. Unfold your own myth.

Rumi

You also need to pursue support on how to deal with the new person in front of you. Reach out and do not pretend you are okay when you are actually experiencing yourself as helpless. Visit a professional.

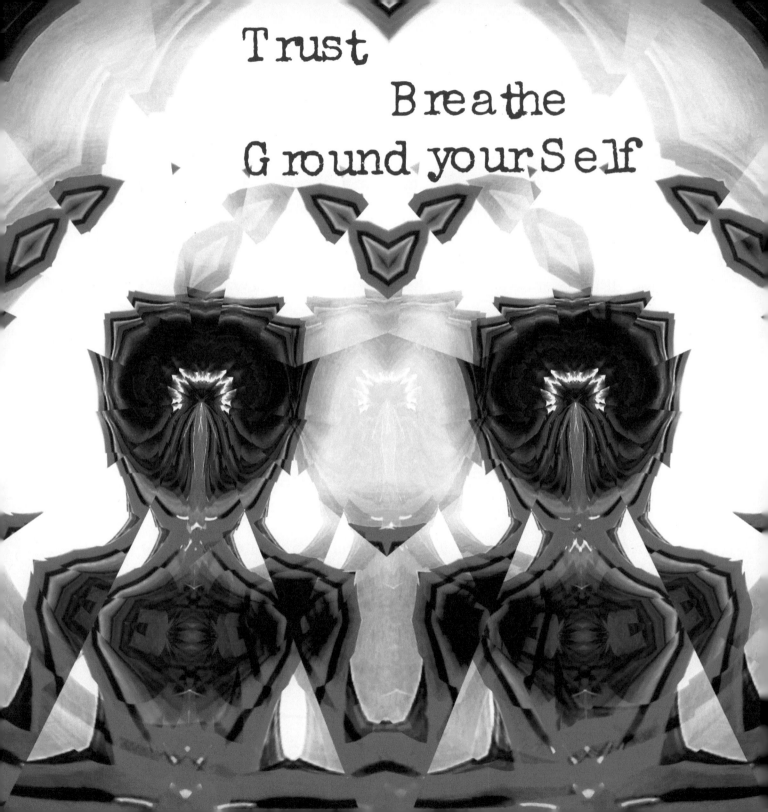

Trust
Breathe
Ground yourSelf

I was agitated, upset and anxious. Sleep eluded me and the fear of not being around and the fear of walking around like a freak was always on my mind. The search on the internet to connect with someone who looked like me proved futile which made the agitation worse. There was this quiet hum of doom running in the background of my mind. When will it stop?

As the water of the ocean sweep over my feet in the sinking sand, I close my eyes and relish in the peace of the ocean. The rhythm of life pulsates through to the fiber of my soul connecting me to nature. I relax, I breathe, and am grounded.

Judy-Lee

Allow your loved one the ability to relax and recharge. They are confronted with questions and scenarios that have no reason for existing, yet for them it is real. They are nervous, anxious and love provides a sense of security.

Have you thought about what size you want to be?

My body gave me breasts. The consistent relationship with my body since puberty has never been challenged as it is being challenged now. How do I measure what is a good size? I was just my size. And then there is the curiosity of going larger. What if?

When you are content to be simply yourself and don't compare or compete, everybody will respect you.

Lao Tzu

If you think about it, this is not a normal inquiry to be in, if life was just being lived. So do not be rude and pushy. Be in the inquiry with your loved one as to what could make them comfortable, not necessarily happy.

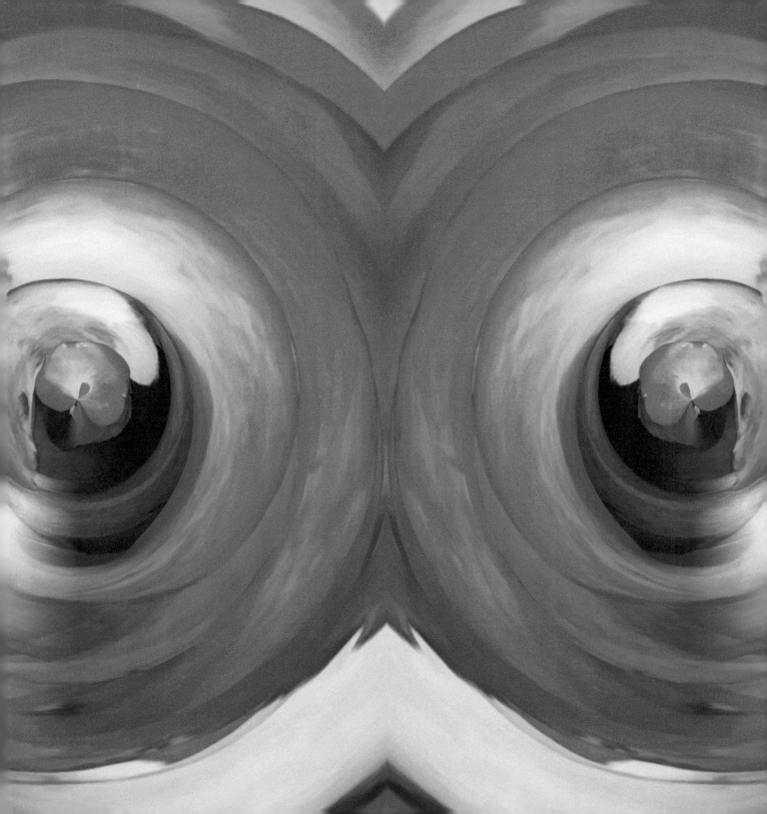

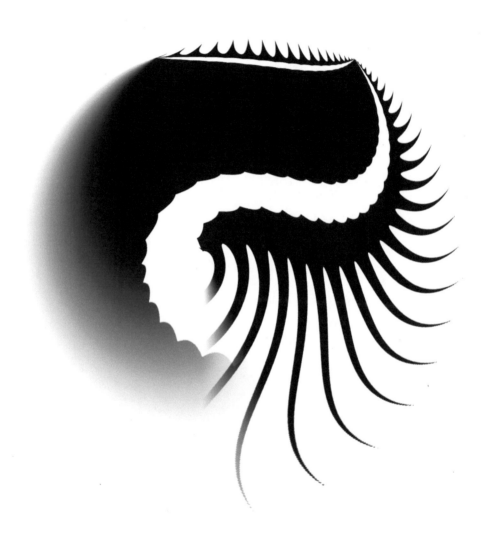

Can I close my eyes and see nothing? Can I think about nothing and stay that way? Peace is sought and cannot be found. Sleeplessness penetrates and causes confusion and despair.

Silence is a source of great strength.

Lao Tzu

Insomnia is one of the side effects after mastectomy. Ensure they are letting the healthcare professional know about this so it is addressed. You get to be their healthcare advocate in everything. Do not assume they are sharing everything. Provide yourself with the proper care which includes sleep and nourishment.

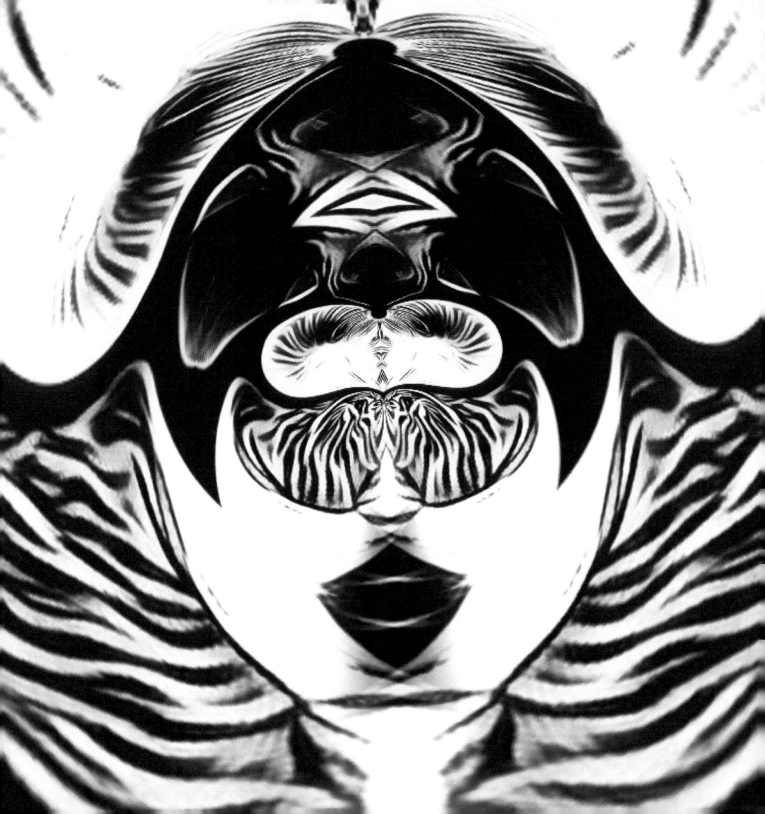

There is so much information to gather and to process and sort through. There are pamphlets and forms and websites and more information, yet it does not give you the real information you need to choose. This burdens the spirit and fills the crevices of the mind with fear, doubt and pictures you cannot face. How do I choose? What is truly best for me? Where do I find the answers?

I know you're tired but come, this is the way.

Rumi

Sit down before appointments to find out what are some of the questions to be asked. Write them down. Find ways to be there for every appointment and take notes. Ask the questions and get the answers. Later process notes together.

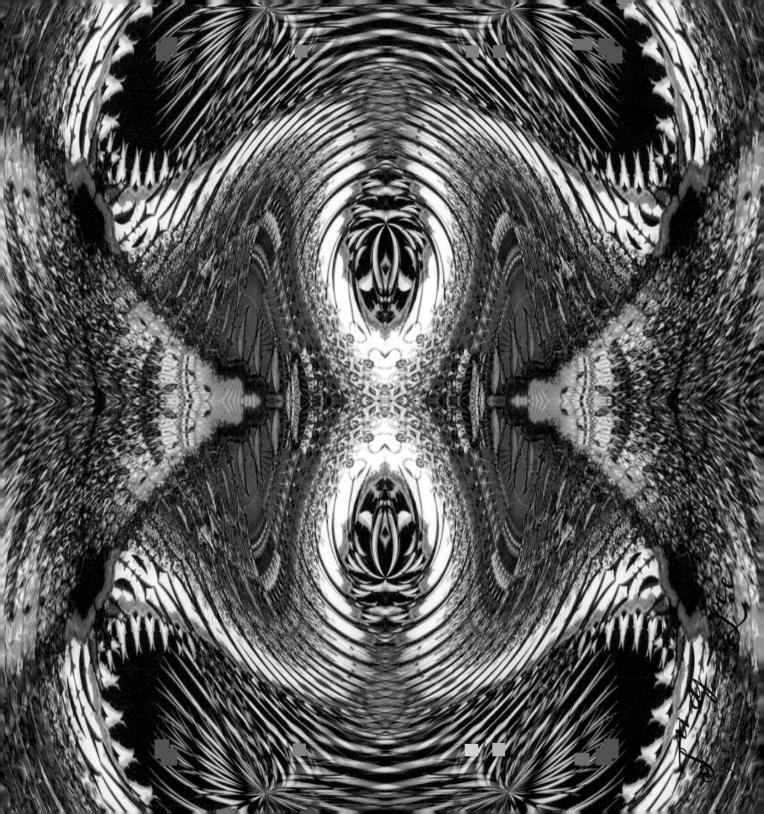

Like an iron girdle around your waist to hold and form and shape you, the iron bra on the chest is a constant reminder that life will never be the same. Expanders are known as the most horrific process. It is stretching and aching and itching and painful. It feels like it is a never ending part of the journey. Some day it will end. I pray.

‖ *The best fighter is never angry."*

– Lao Tzu ‖

Ask questions as it may take their focus off of the discomfort and pain. Be curious Be curious about what it is like for them and above all, listen.

It is time to get the stench, tape residue and blood from the surgery off the skin. The fear of what it will feel like having running water flow over this new terrain. The water flows, and the realization that you feel nothing. A vacuous space between the neck and belly. You look down and see the water flowing and it hits you, I feel nothing. As you clean yourself there is a hollowness and the tears streaming down your face blends with the showering water. Tears continue flowing.

Tears are nature's lotion for the eyes. The eyes see better for being washed by them.

Christian Nestell Bovee

Many tears will fall. There is nothing wrong with that. Express it and know you are healing too.

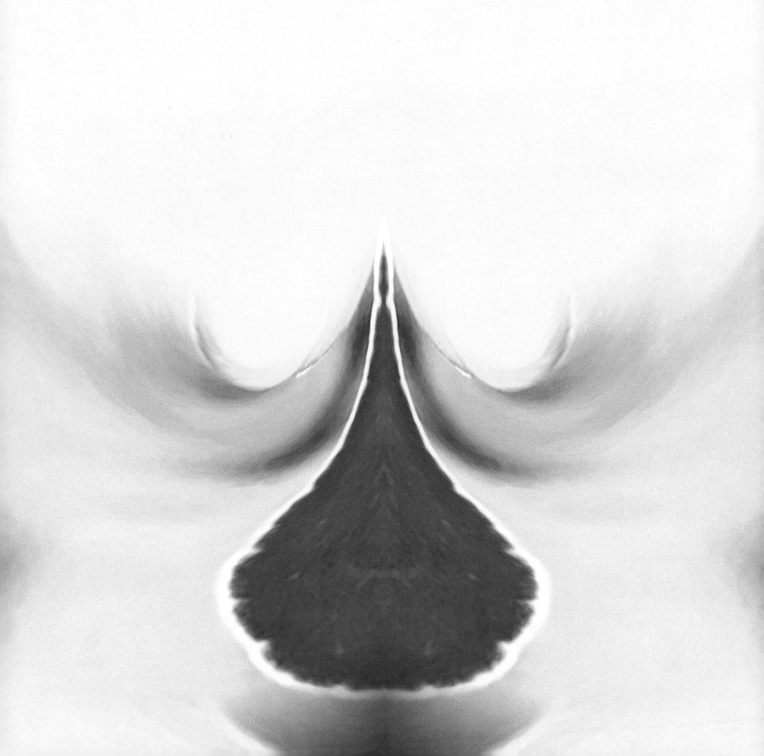

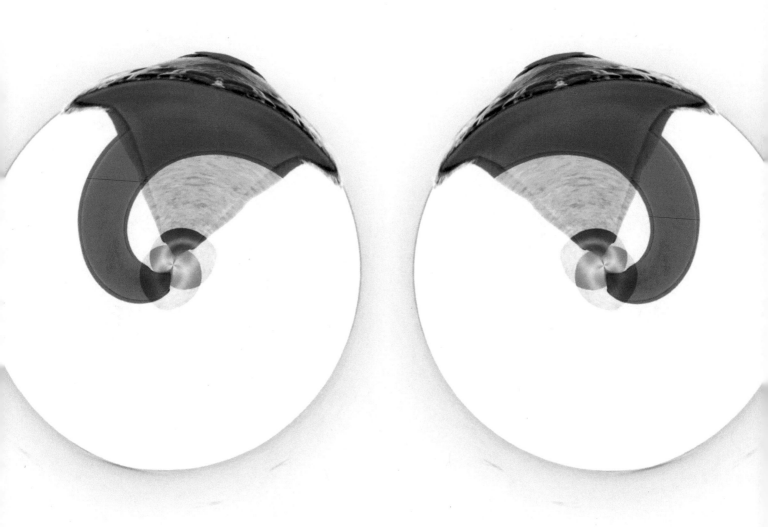

I really am happy with my old racks. Never been my desire to have "racks".

> *When you are content to be simply yourself and don't compare or compete, everybody will respect you.*
>
> *Lao Tzu*

Please do not refer to breasts as "racks". It is offensive and insensitive during this time of turmoil. Never assume that all women are dissatisfied with their current breasts and situation for some.

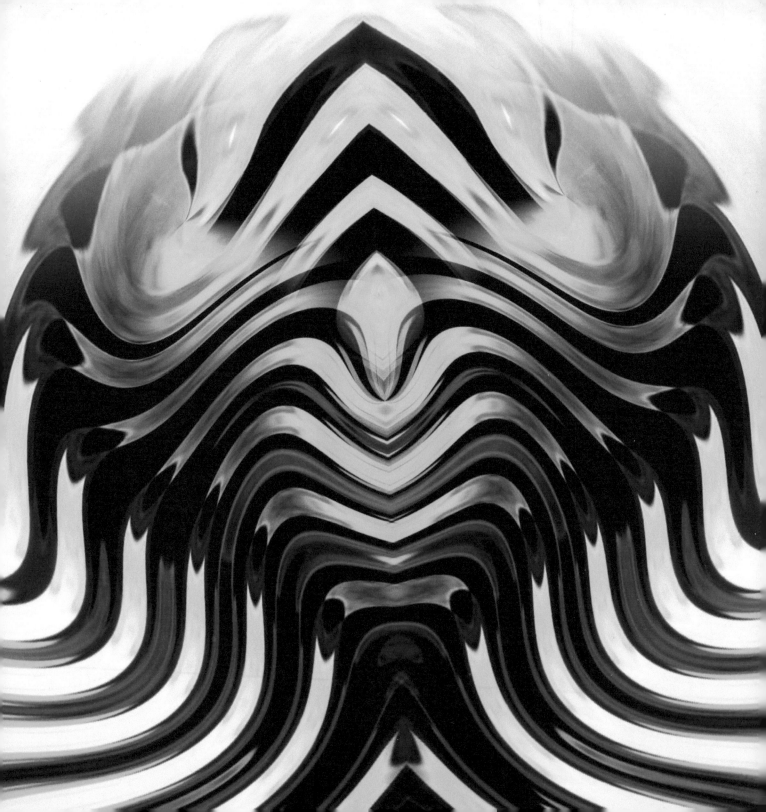

I am always tired and cannot explain why. The monster is in me. It is growing and multiplying and I can't get answers as to what type it is, or what stage. They say I have to wait until I have the surgery to get the answer. So if they don't know, then why am I rushing to mutilate my body? What am I panicked about? No one can give me the answer so I can make the "right" decision for me.

Peace comes from within. Do not seek it without.

Buddha

There is more than one way to support your friend. Constantly questioning them does not help the situation. Be patient as they digest the information.

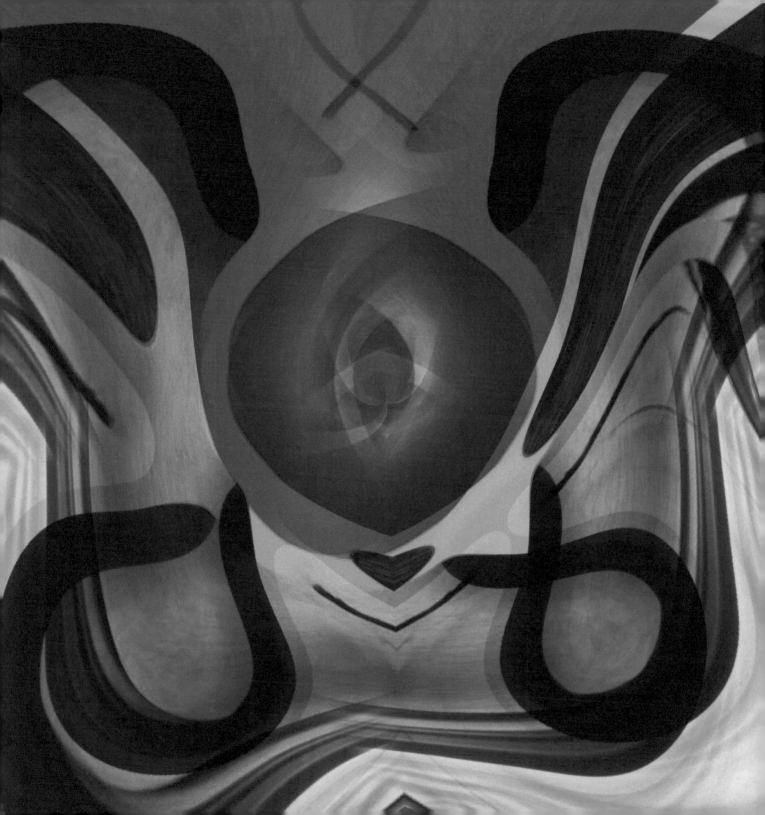

The pain from the expanders is unlike anything you can imagine. The doctor tells you expanders are needed so you have space to do the reconstruction. People tell you it's the worst pain you will ever feel even after the surgery. You think, but I want to have breasts, so I will do this. And you regret it every moment of every day until it is no longer there.

|| *Courage is grace under pressure…*

Ernest Hemingway ||

Women: The doctor tells you to imagine bricks on the chest and a wet bra on 24/7.

Men: imagine bricks on your chest that you cannot get off underneath a too small wet t-shirt.

And added to that, sharp electrical shocks going through the chest.

It's real.

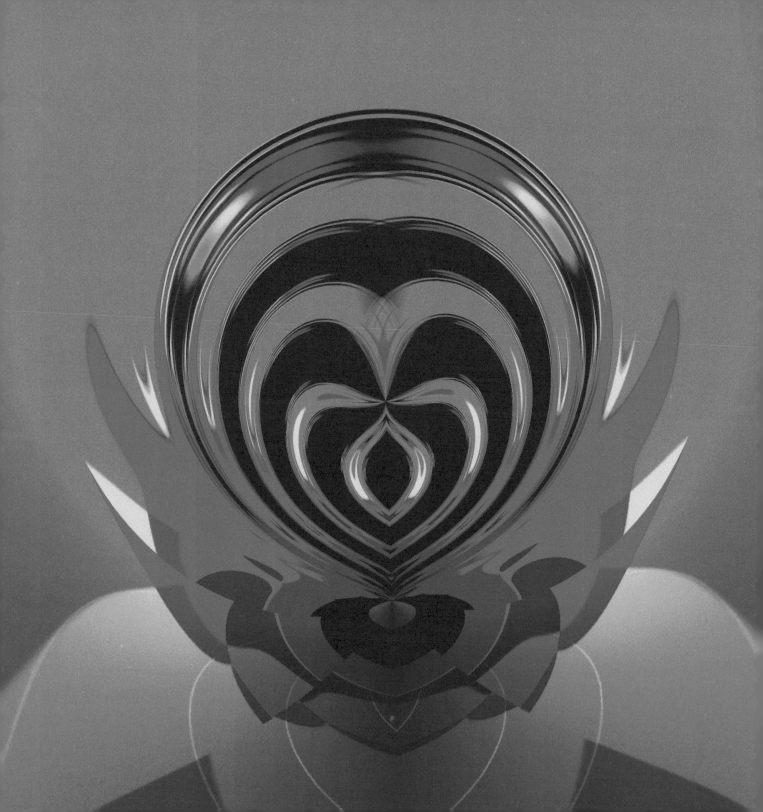

I must get up and get back to doing things normally. Then you take a breath and realize there is a new normal. Can't raise my arms above my head. I don't have the same range of motion. I am off balance. I walk hunched over and no longer straight. I can't bend to pick up things. I am dependent on others. There is no going back. There is only now. Do not be satisfied with stories of how things have gone with others. Unfold your own myth.

|| *Our greatest glory is not in never falling, but in rising every time we fall.*
Confucius ||

If you see them struggling, jump in and show love. They may reject it. Encourage them gently and if they still do not embrace your offer, please do not judge them during this transition time.

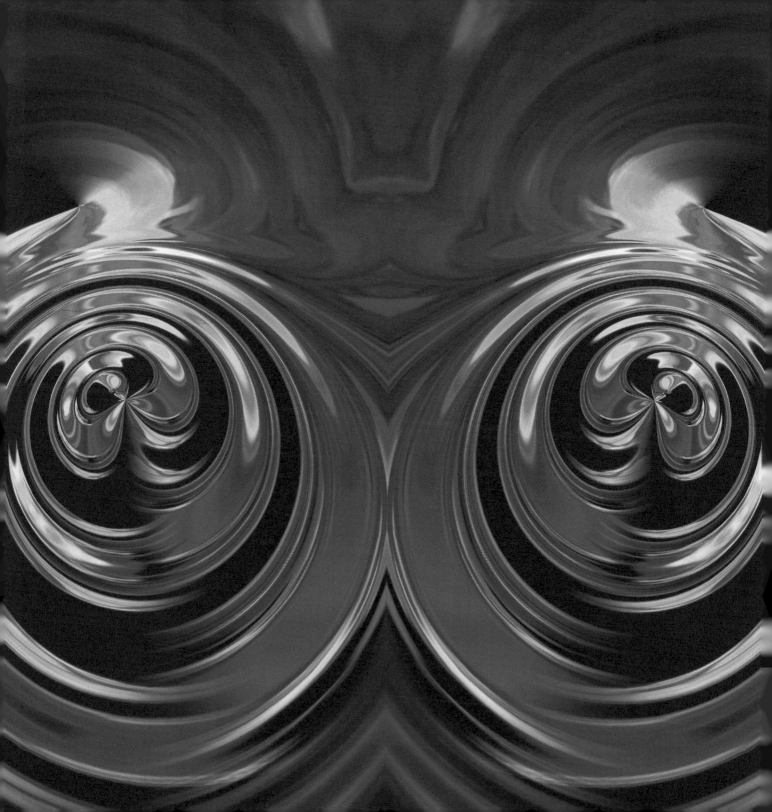

As you wait in anxiety for what is next, your mind plays tricks on you. All there is to think about are breasts. How big, how small, nipples, no nipples, tattoos, no tattoos, implants or no implants, DIEP surgery (breast from your own body fat & skin) or not. And then no breasts at all. The horror to even suggest this option. What do I do? God gave me my breasts, I don't know what will look good on me. Help!

 I choose

Judy-Lee

Once their mind is made up embrace it and empower their choice no matter your thoughts, feelings or emotions. Remember it is their body and choice.

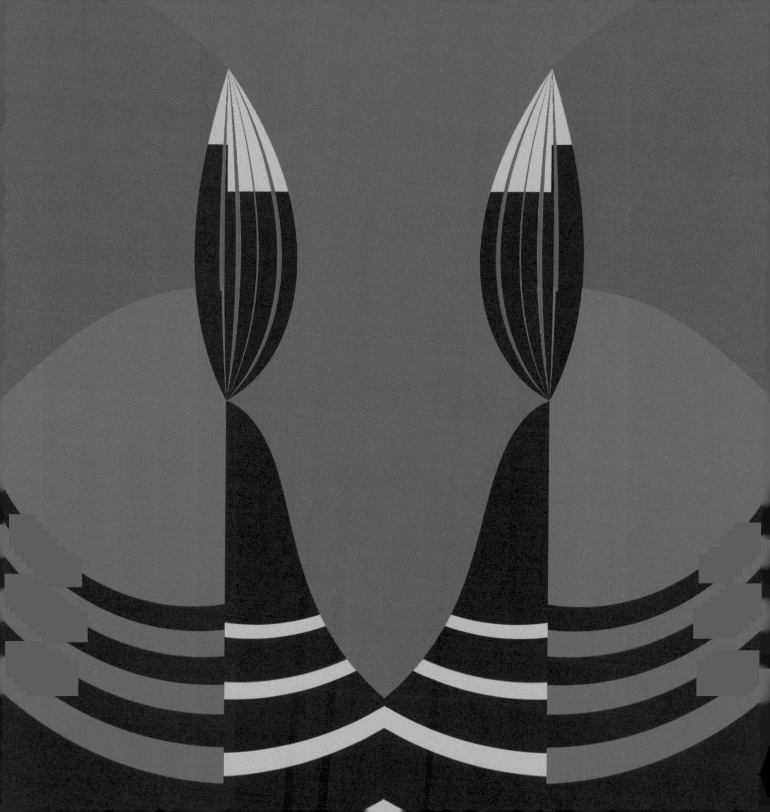

Family and friends rally around every step of the journey. There are meal trains, and visiting trains and hello call trains and funding trains. Every step of the way showing an expression of being known and loved. This is one of the most instrumental pieces of hope and joy there is. Knowing that there is no being alone on this journey provides solidarity. In the quiet moments it brings joy and courage in the most desolate of times. It is what keeps us going forward and not quitting.

‖ *From caring comes courage.*

Lao Tzu ‖

We thank you and love you for everything you deal with on your own to take care of us. We may never know the courage it takes you to be courageous for us.

There are many forms of trying to keep one's composure in the face of an impending finality. One such way is to accept what is so. The body is being altered. It is being ravaged by an inexplicable mass of nothingness. The part of the body you have come to know for some time is no longer yours. It is alien to you. What matters is finding a way to explain it to yourself. Amputation. Yes as it is the action of surgically cutting off a limb. I am an amputee gives me solace, a place to stand and absorb what is so.

|| *Don't grieve. Anything you lose comes round in another form.*

Rumi ||

For you it may sound incredulous as they refer to themselves as an amputee or hear the word amputation. For the mind to restore itself, it must find new paths to accept what is no longer there. This gives them peace and the ability to process.

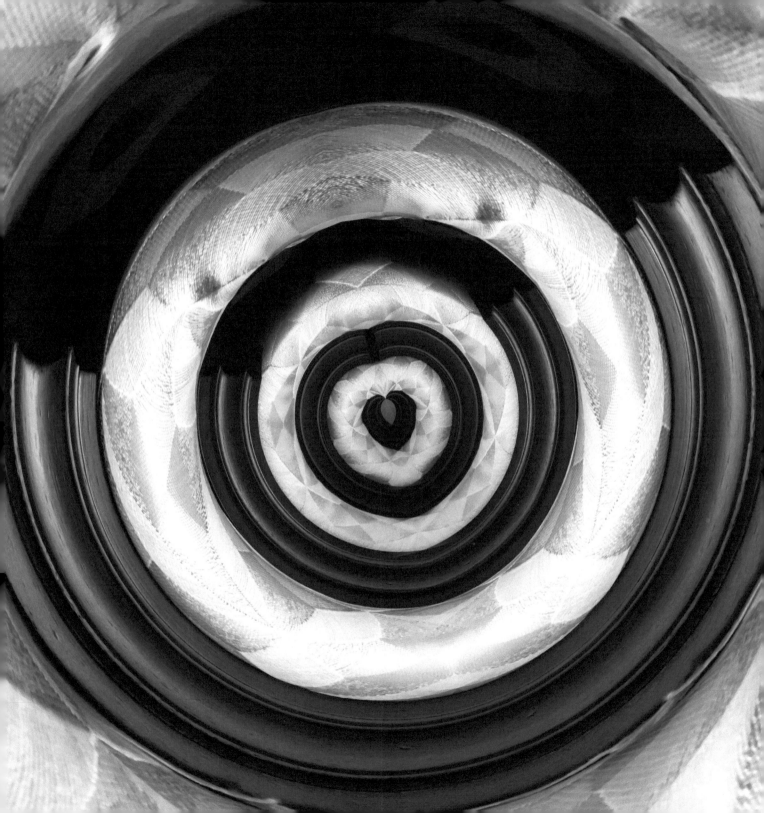

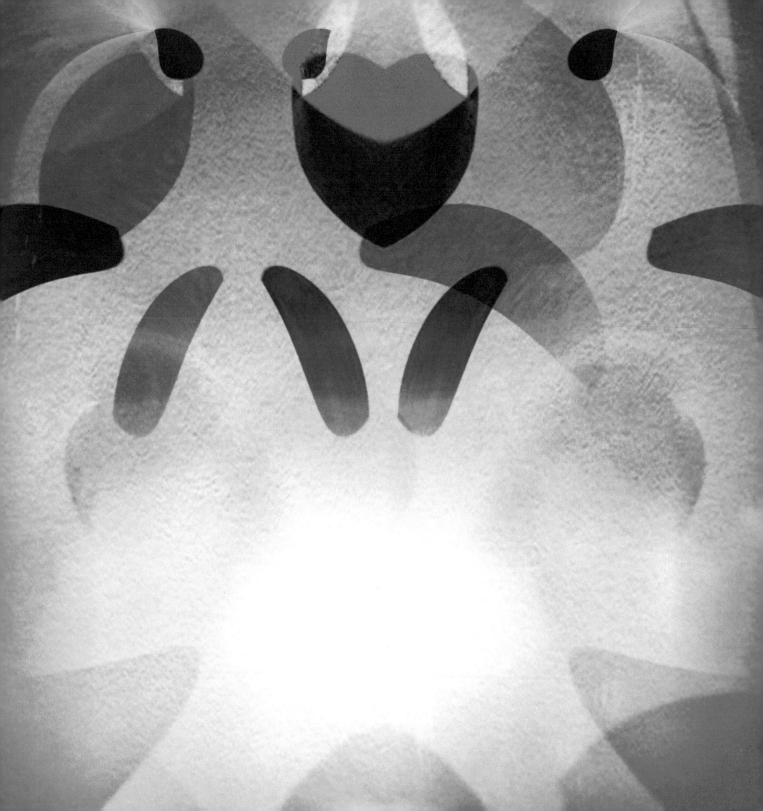

There is a moment when all the pain, all the despair, all the anger and solitude fades into the background and there arises a surrender knowing that this is the way life is. There is nothing more to do or say, it is the way it is and life continues in spite of it all.

One cannot reflect in streaming water. Only those who know internal peace can give it to others.

Lao Tzu

Allow your loved one the space to find their own space and humanity.

Hopelessness, inadequacies and the feeling of uncertainty envelopes your every thought once the idea of living without breasts becomes a reality. For those whose idea of womanhood includes their breasts it is even more difficult to wrap your thoughts around life without breasts. It consumes you and the colors of life dims.

|| *We should feel sorrow, but not sink under its oppression.*

Confucius ||

Hang in there, you too are going through a journey unlike any other. Take some time off and recharge yourself. Be kind to yourself and find the humor of life in the things you do and see.

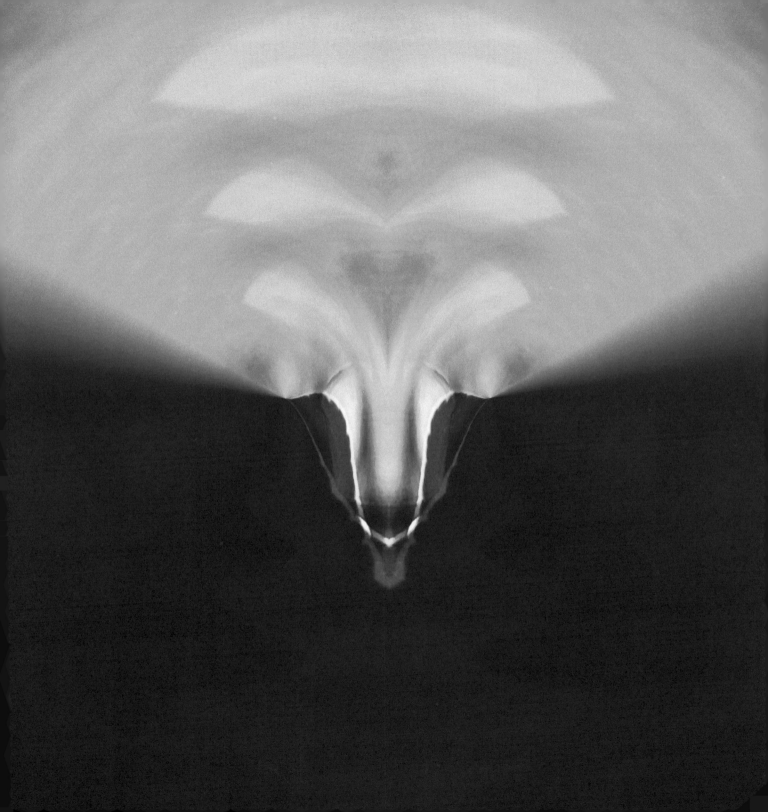

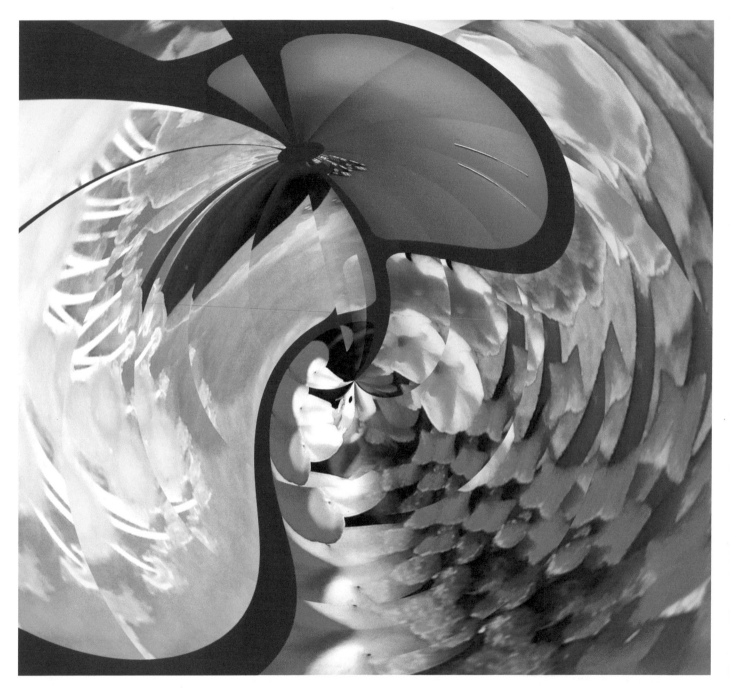

This picture is named Rebecca in honor of a precious beautiful soul who lost her fight yet left her indelible mark on my soul.

Rebecca

There are people in the world who you may never meet in person who impact and inspire your journey. The conversations are sometimes few, however, who they are after their journey is pure joy and inspiration. Rebecca was that person for me. She was vibrant, alive and showed no mercy in her love for herself and body after fighting cancer and mastectomy while devoting herself to her children and husband but most importantly to each and every new person who showed up in her life going through or starting the journey.

‖ *It isn't what we say or think that defines us, but what we do.*

Jane Austen ‖

Find a Rebecca or be a Rebecca for your loved one to be around.

I am woman. I am feminine. I am strong. I am a mother. I am a daughter. I am vain. I am a nurturer. I am …

Then the prospect of being a woman without breast starts to look like... I am not whole without my breasts. I am not woman without my breasts. I cannot nurture without my breasts. I cannot be vain without my breasts… I cannot be woman… Then as time heals, who am I? Am I just my breasts? And the answer to that is a discovery.

We know what we are, but know not what we may be.'

Shakespeare

Being in the unknown of who you are and what your purpose is doesn't stop or start in an instant for some. It's a journey. Are you willing to walk with your loved one as they discover it for themselves?

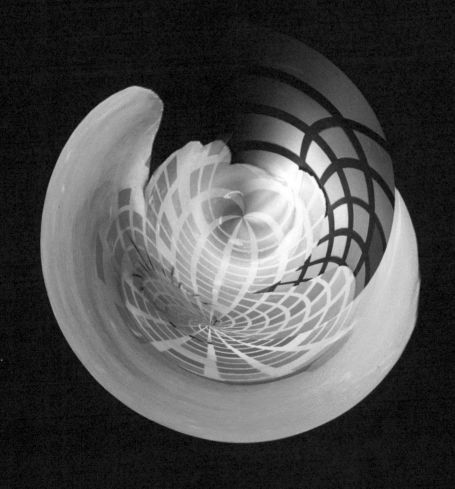

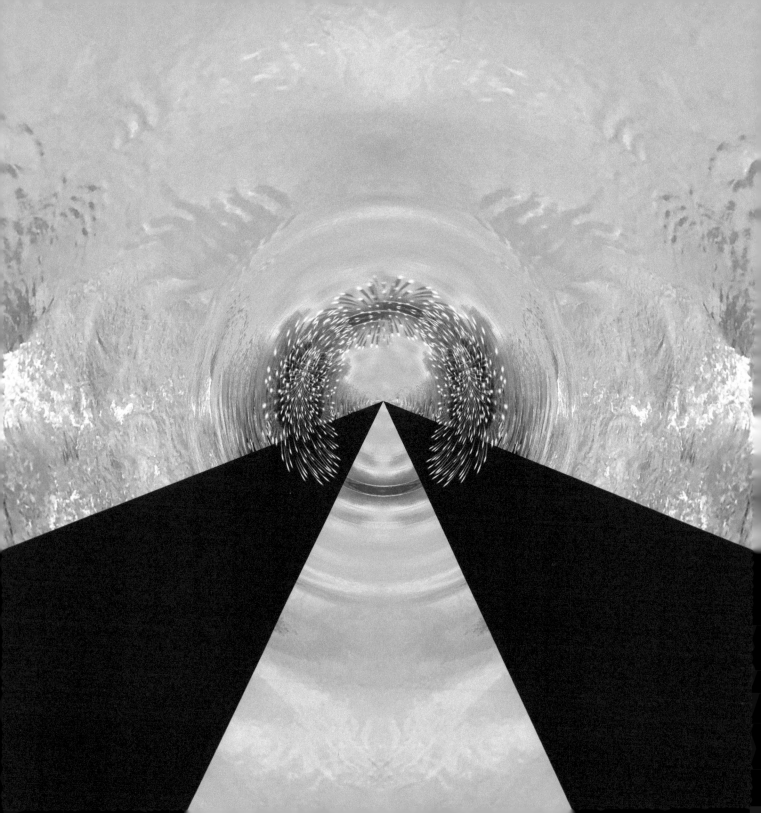

There is a light at the end of the tunnel. And the tunnel's end is up to you. One cannot reflect in streaming water. Only those who know internal peace can give it to others.

Judy-Lee ||

The first time you feel cold water travel through your breast cavity gives you pause. Did I just feel this? Is this supposed to happen? And then you try to remember how did you swallow water before? That is not a normal thought because you don't think about what happens when you swallow water. You just swallow. One more thing that is different.

|| *The things that make me different are the things that make me.*
– Winnie The Pooh ||

They may say something that borders on crazy in your view. Be in the inquiry with them, hear them out. They are usually not going insane.

Finding the way to freedom from the mental anguish that is mastectomy is a personal journey. Some find it freeing right away. For others it is what has to be done so get it over with. Some accept the outcome and feel fear and rage of "why me". And for others like me we dread the vision of a body scarred and cannot wrap our heads around it. It is a lonely journey like walking down a country road when it's dark and only sporadic lights are available from time to time.

It is strange to be known so universally and yet to be so lonely.

Albert Einstein

No matter how much you tell your loved one that it will be okay, the vision they have for themselves needs to be illuminated in their mind's eye and only then can it be a reality. Patience will be your ally.

The rhythm of life keeps drumming around you. The sun keeps shining, then it sets giving rise to the moon marking the end of another day. The body does what is necessary to heal and the mind dances to its own tune. It ebbs and flows like the waves caressing the shores whilst during a storm it bursts upwards and crashes on the rocks. It dances to its own beat as the healing keeps challenging the breadth of what you know. It is in the moments when you find the courage to laugh at yourself where life begins to happen. It is in those moments tranquility abounds.

|| *To truly laugh, you must be able to take your pain and play with it.*

Charlie Chaplin ||

Find ways to bring humor to the situation. Find great jokes and funny situations to share. And remember, that time may not always be right for your loved one.

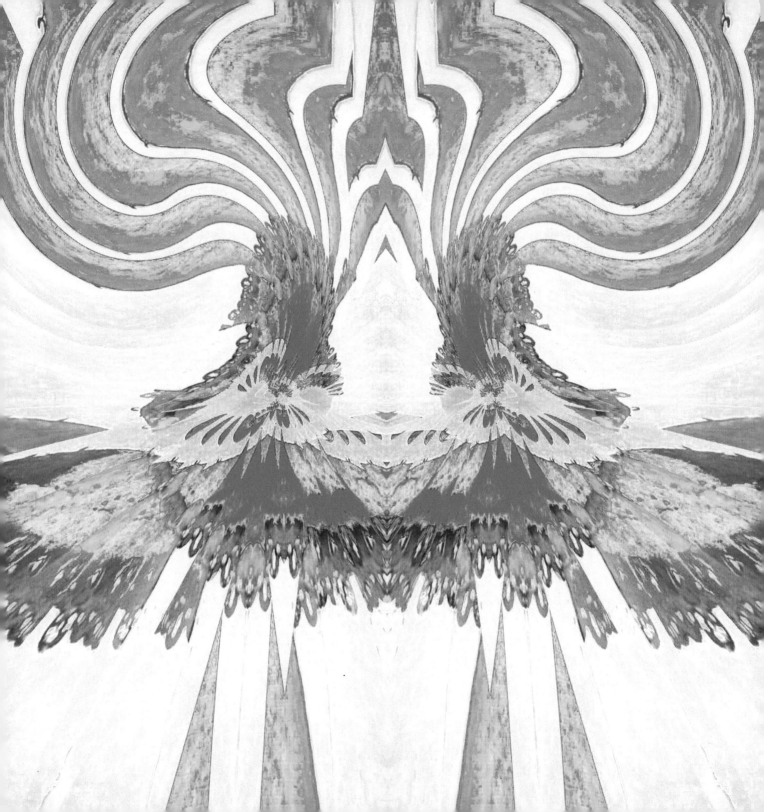

Iron Bra = Expanders

You are given options to have the illusion of breasts to give yourself the chance of feeling womanly again. This apparatus is sewn onto your chest muscle and filled with saline to hold the space for your future "breasts". Everyone says you look good, I can't tell you had a mastectomy. Yet beneath the fabric that covers you, is one of the worst agonies to go through. Sleepless nights, pain in the chest 24/7 and the illusion that it will get better. It's the vision of an illusion that someday you will feel whole again. All for what?

‖ *Nothing is more sad than the death of an illusion.*

Arthur Koestler ‖

There is real pain and discomfort with expanders. Bring compassion to the forefront.

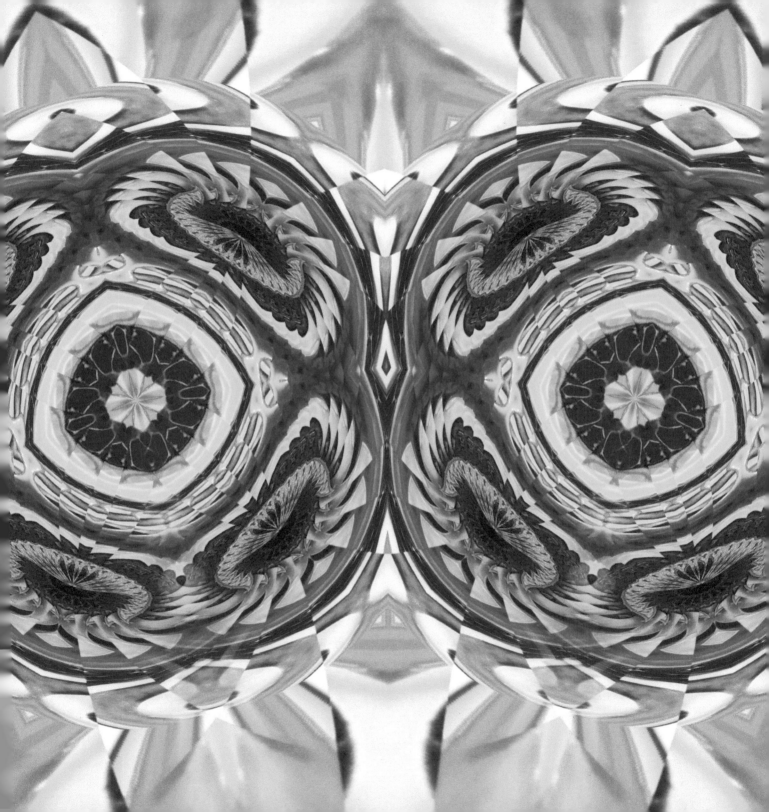

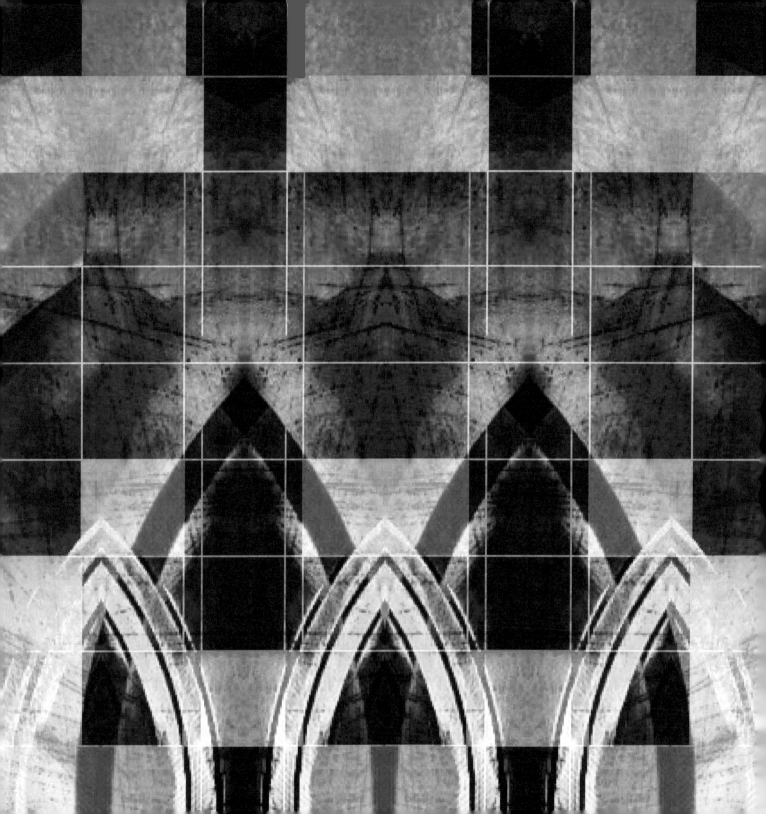

One would think that taking off two breasts would have you lose weight! Hilarious thought. They don't amount to anything. So you now get to climb a steeple. Several reasons for weight gain - chemotherapy and radiation. And there is the underlying fact that the body has been depleted of valuable nutrients over the time it takes to grow a tumor. That is my road. And as it cannot come off, I change lanes on my journey.

When it is obvious that the goals cannot be reached, don't adjust the goals, adjust the action steps.

Confucius

With the issue of weight loss, be the supportive link for your loved one.

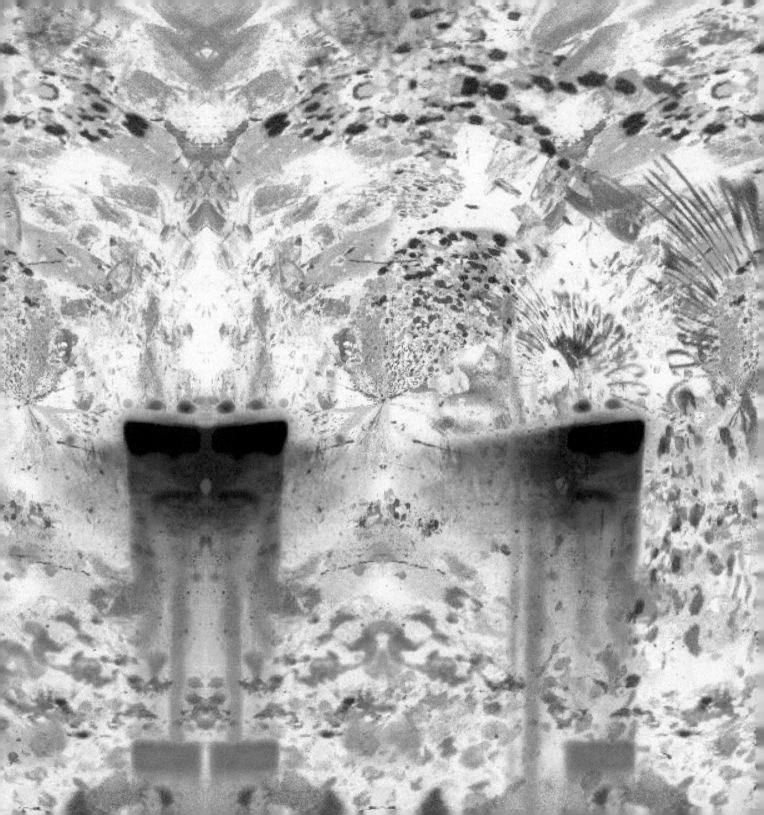

My body was mutilated. I continued to hear, don't say that, you are having your life saved. You are lucky.

My body was mutilated and it doesn't mean I was not interested in saving my life, nor that I do not appreciate that I live…and my body was mutilated.

The truth is not always beautiful, nor beautiful words the truth."
— Lao Tzu

It may sound harsh to you and for sure it does not negate what your loved one is going through. Embrace it.

Silence is a source of great strength.

Lao Tzu

To put one foot in front of the other and not fall was only possibly by the fierce team of heroes who supported me, helped me love me and guided me. They were the concrete foundation that provided the solid ground on which to walk the path.

‖ *We must build dikes of courage to hold back the flood of fear.*
Martin Luther King, Jr. ‖

Everything is possible when there is a sense of love and contribution.

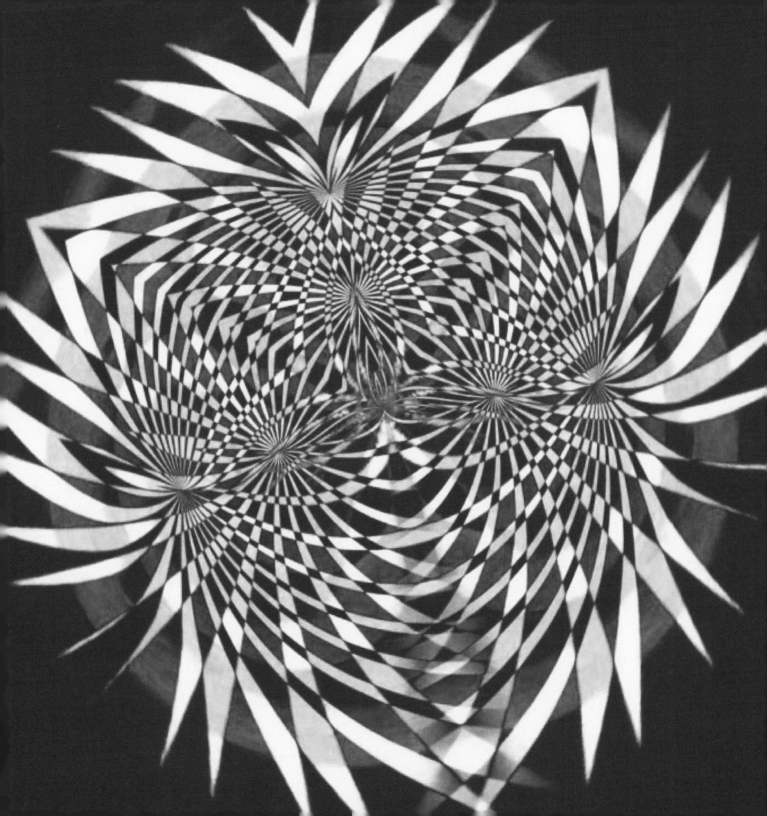

I will never forget the moment that everything came into place. I went walking before my final appointment with the plastic surgeon. It was a still summer night with a gentle evening breeze blowing. I looked up at the sky saw the moon and said to my sister in heaven, who had died of breast cancer, "what do you think I need to do?" There was an immediate calm that surrounded me. It was comforting and soothing and warm. I knew the answer. You will know yours.

I have learned over the years that when one's mind is made up, this diminishes fear; knowing what must be done does away with fear.

Rosa Parks

Give them the space and time to find their inner peace.

Going out in public for the first time without breasts is scary and unsettling. I remember putting on my favorite dress to go to a business meeting and when I looked in the mirror tears cascaded down my cheeks. I protected myself from tears and hurt by not looking in the mirror.

Tears are the summer showers to the soul.

Alfred Austin

Can you hear their silent cries? It is there.

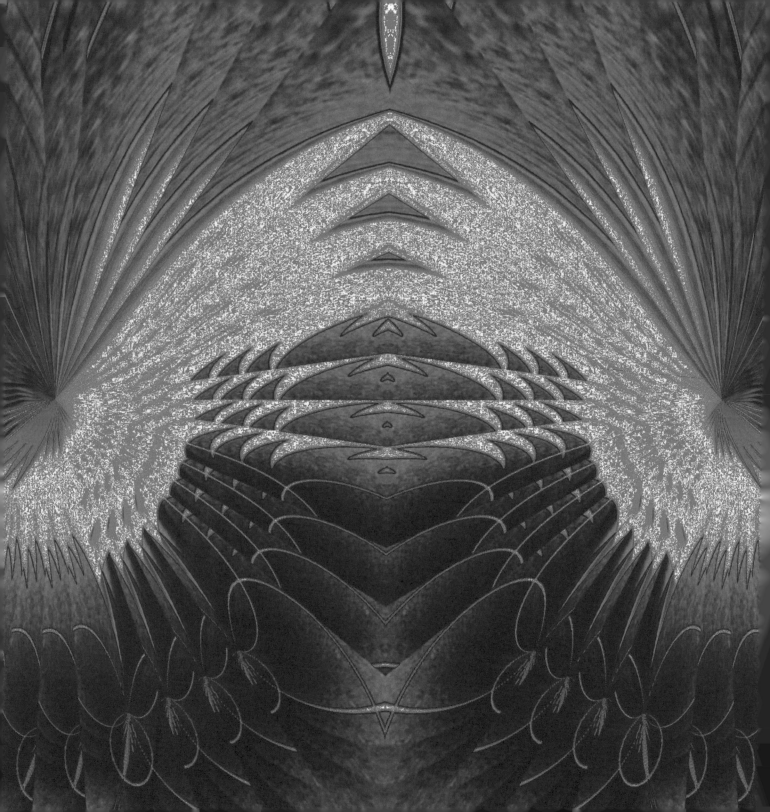

I am a hugger. I want to hug. I want to give hugs. I love to clap and acknowledge others. With expanders hugs became painful. The pain lingered for 48 hours and clapping was no longer an option. This intense pain was caused by sutures tearing away from the expanders. I learned that another surgery was the only way to rectify this painful issue.

‖ *The pain will leave once it has finished teaching you.*

Unknown ‖

You hurt as they hurt. Find ways to comfort yourself as you cannot alleviate their pain.

My fear of having my breasts removed propelled me to launch aggressive research. I soon learned about the different surgical incisions and cuts. I learned about nipple sparing. I became an informed candidate and actively participated in my mastectomy journey. We must take control.

> *There are times when fear is good. It must keep its watchful place at the heart's controls.*
>
> *Aeschylus*

The fear that you have is valuable when you use it investigating information to assist in processing the task at hand.

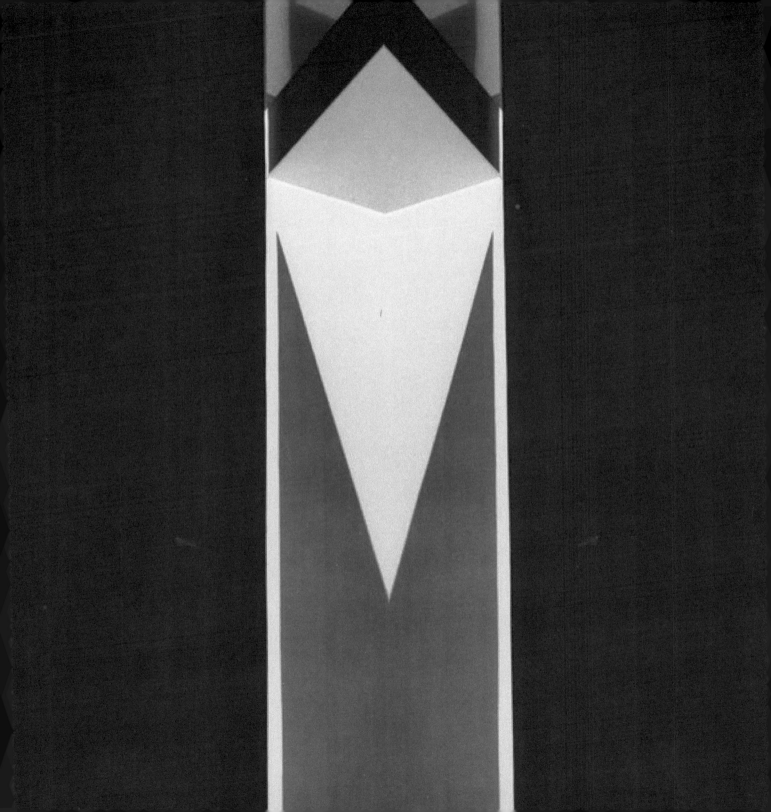

I continue to blossom like an exquisite rose as I take my walk through cancer and mastectomy. As the moments unfold like the petals uncoiling from each other, I see how much my life has expanded and my willingness to reach beyond my comfort zone has grown to new heights. My mind has been opened and expanded even though I have certainly stumbled and fallen, only to awaken to bloom radiantly and with strength.

|| *I've learned more from pain than I could've ever learned from pleasure.*
Unknown ||

Your loved one is forever grateful for your time, generosity and being their strength.

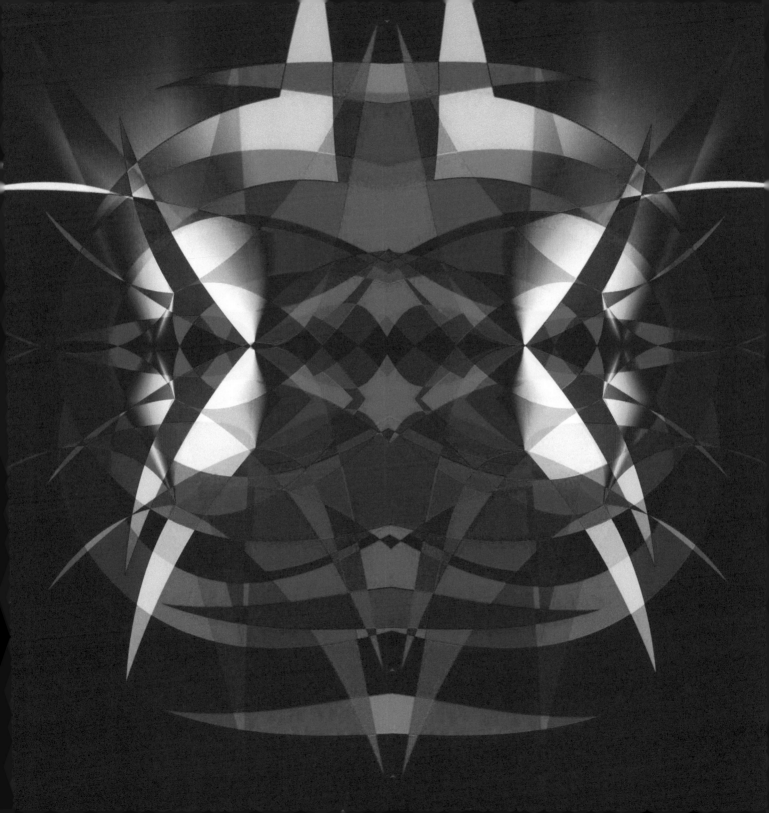

When I heard, breast cancer, for a few moments my mind raced through the scenario of death. In an instant, I realized I had become comfortable with death. My stark reality was existing without breasts.

Even death is not to be feared by one who has lived wisely.

Buddha

Sometimes death is not their worry. What is your fear? Confront that to be able to be there for your loved one.

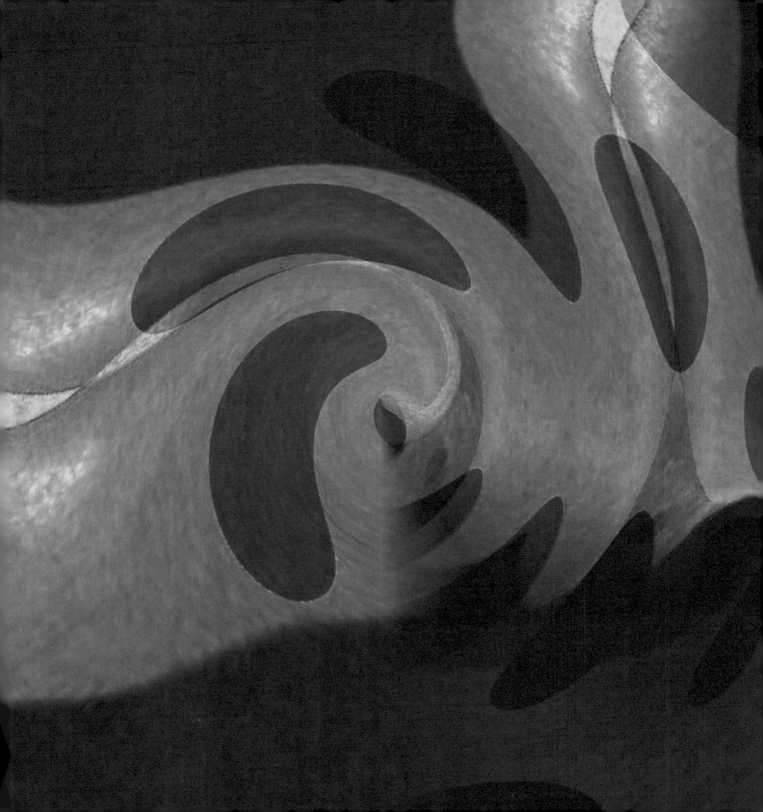

I hope to God this pain subsides. I hope I get some sleep tonight. I hope it is not cancerous. I hope I can have the surgery I want. I hope I have chosen the correct surgeon. I hope I can heal properly. I hope I will like how I look. I hope it is all gone. I hope this year's blood work comes back negative. I hope this pain is not cancer again. I hope I will find someone to love me. I hope people don't leave me. I hope I can take care of my finances. I hope I am not a burden. I hope…and I hope… This is what keeps me going from day to day.

Hope is being able to see that there is light despite all of the darkness.

Desmond Tutu

In spite of their gloom and doom inside they are hopeful.

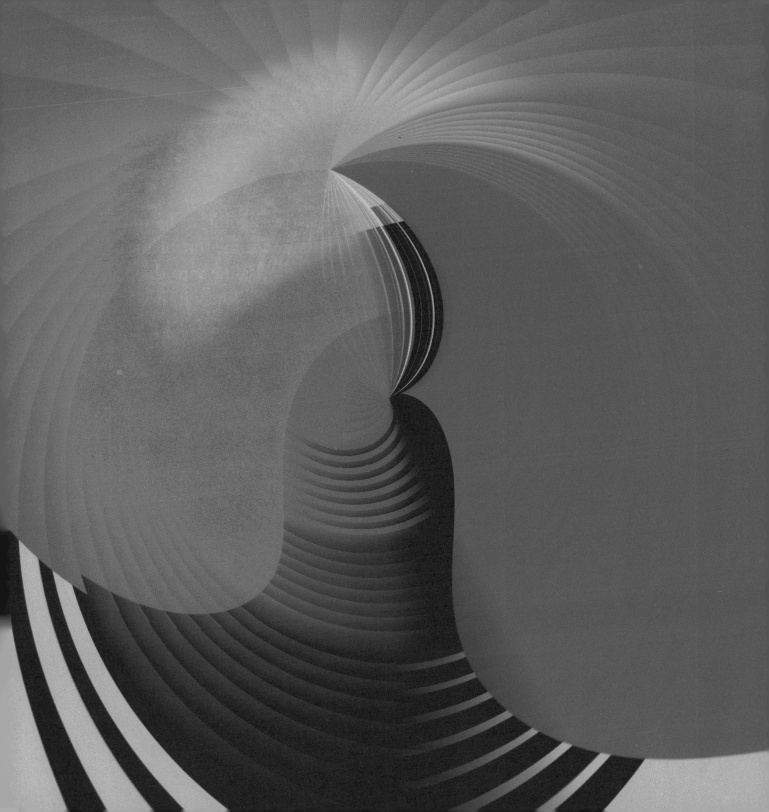

Imagining how the expanders sewn into my chest was going to be filled was far from the reality of what unfolded. I imagined pain and some sort of anesthetic. As I lay wide awake while the surgeon placed a needle of saline into the port in my chest, he distracted me with jovial conversation. Before I knew it, it was over and there was no pain. It was strange.

The only courage that matters is the kind that gets you from one moment to the next.

Mignon McLaughlin

Be inquisitive and be available to go with your loved one.

There is an inviting stillness in the air just before the impending chaos daylight brings. The same is true for the process of going through the wrenching rigors of mastectomy. There is life inviting you to play and then you are catapulted into shock, hopelessness, resignation and fear which cloaks and wraps your inner core. Over time this dissipates into numbness and a quiet resolve to push through with all your might. Then one day life revives itself, awakening your ability to see the beauty, smell the sweet smells and enjoy the richness of living. You realize you can fly!

|| *Sad things happen. They do. But we don't need to live sad forever.*

Mattie Stepanek ||

It does take time. It's their time not yours.

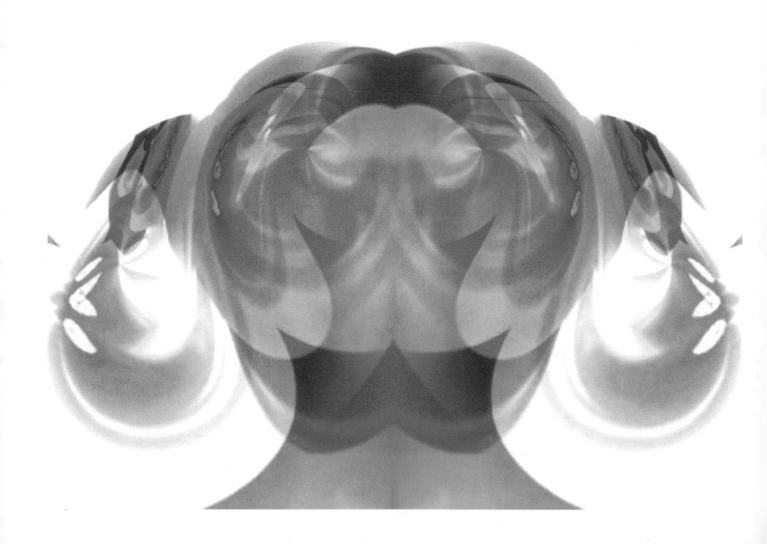

Simple things cannot get accomplished once the surgery is completed. You cannot raise your arms above your shoulder, so can you imagine what it is like trying to comb your hair. Impossible. Dressing, sitting and getting up from chairs all use the chest muscles. You will discover how many things require the chest muscle and in those moments it hurts.

|| *He who knows himself is enlightened.*

Lao Tzu ||

There are many more things to learn during healing. Ask how you can help with the small things.

What does cancer look like? What does the tumor look like? Why didn't you know? How did you find out? I had discharge. I had dense tissue which was a part of my mammogram history. I would feel what I thought was a lump or growth and my mammograms always came out negative. I didn't have a mammogram in about one to two years. I did feel a dense lump and was waiting on insurance to renew. Then there was discharge. And I knew there was something wrong. You never know what it is or when it will come to light. Keep vigilant.

‖ *Don't wait. The time will never be just right.*

Napoleon Hill ‖

Investigate other forms of mammograms.

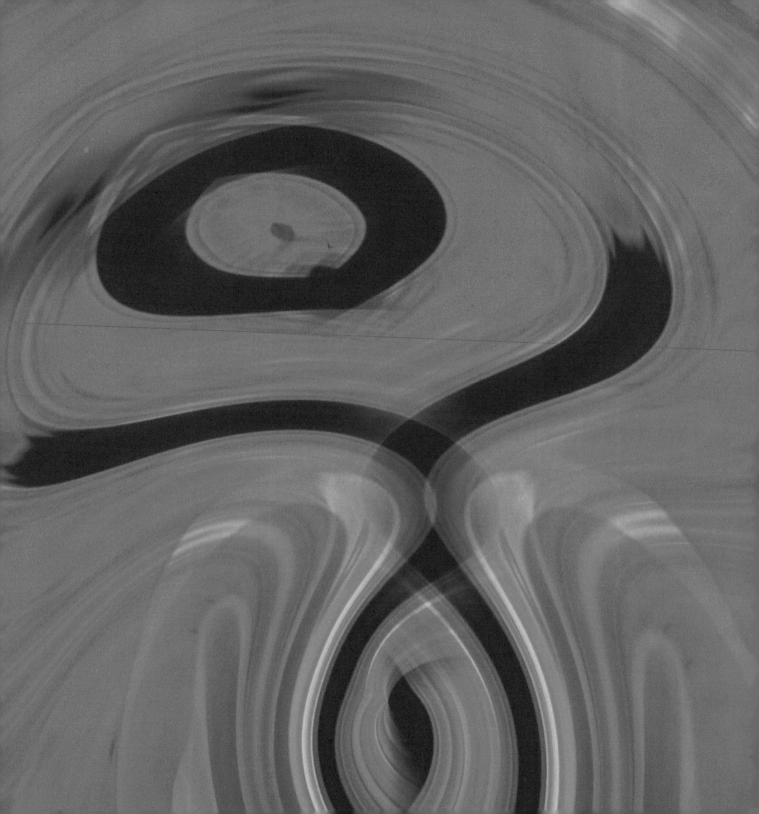

The moment you feel the relief of all the pain dissipating and it is no longer a hindrance to your existence, is the moment you start to dance. That happened when the expanders were taken out after I made the decision to go flat. Through my healing I discovered my womanhood is not my breasts.

|| *All things in the world come from being. And being comes from non-being.*
– Lao Tzu ||

Support the decision no matter your personal feelings.

There is life before mastectomy and there is life after mastectomy. After brings about sometimes unanswerable questions. Will the cancer come back? Did they get it all? What clothes can I wear? What will people think? Do they even know or care? What do I say if someone says something offensive? Are people talking about me? Then one day it's like I don't give a damn about what others think and realize this is a gift. A new life, new body - this is the new me. I know I must give back, I know I must make a difference to someone. I know my journey will help someone. Someone helped me.

A timid person is frightened before a danger, a coward during the time, and a courageous person afterward.

Jean Paul

Beneath every action is an underlying fear that it will come back. Embrace your friend and allow them to find their new path in the wilderness.

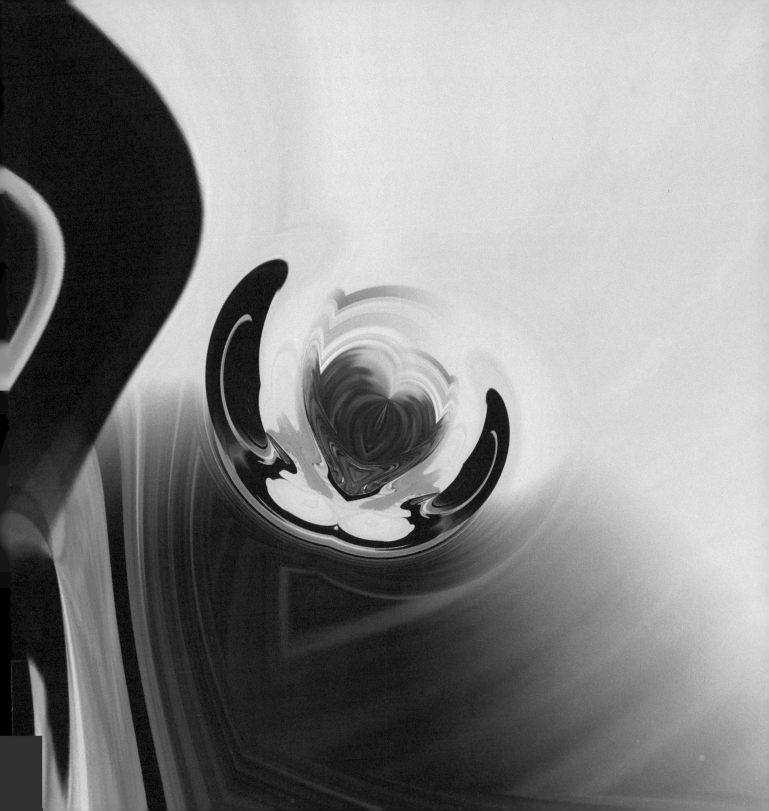

Before & After
Photography merged with technology soothed the soul

 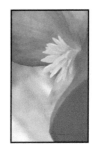 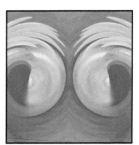

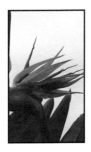 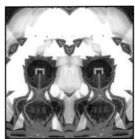 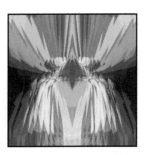

Author

Judy-Lee is a double mastectomy & breast cancer thriver. This picture shows what it looks like 2 months after double mastectomy with expanders not completely filled.

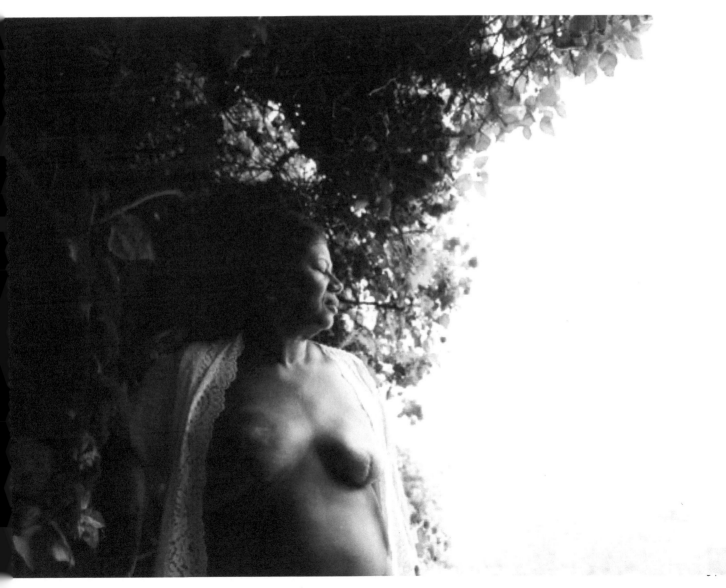

CPSIA information can be obtained
at www.ICGtesting.com
Printed in the USA
BVHW020152090621
609086BV00002B/7